For Barb, Brian, and Kevin
—*M.V.*

For Doug, Ted, Tom, and Davy
—*B.F.*

*This book is dedicated to our families
and to our Mom and Dad*

ERRATA

The caption information on page 11 should read

Left: Daniel Kelly. *The Secret.* Cement block, woodblock, lithograph, handcoloring. Ed. 32. 1994

❀ ❀ ❀ ❀ ❀ ❀

Right: Daniel Kelly. *Straight Away.* Woodblock, lithograph, handcoloring. Ed. 32. 1994

QUIET ELEGANCE

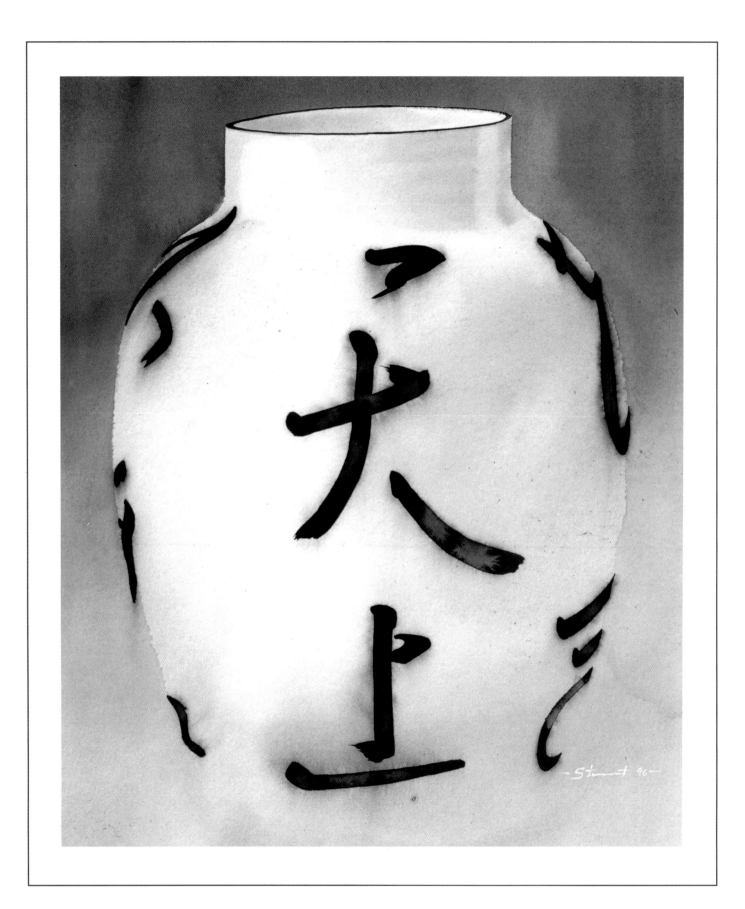

QUIET

ELEGANCE

JAPAN
THROUGH
THE EYES
OF NINE
AMERICAN
ARTISTS

BETSY FRANCO

MICHAEL VERNE

CHARLES E. TUTTLE CO., INC.
BOSTON • RUTLAND, VERMONT • TOKYO

First published in 1997 by Tuttle Publishing, an imprint of Periplus Editions (HK) Ltd., with editorial offices at 153 Milk Street, Boston, Massachusetts 02109 and Tuttle Building, 1-2-6, Suido, Bunkyo-Ku, Tokyo 112, Japan.

Library of Congress Cataloging-in-Publication Data

Franco, Betsy.
 Quiet Elegance : Japan through the eyes of nine American artists /
Betsy Franco, Michael Verne.
 p. cm.
 ISBN 0-8048-3126-2
 1. Expatriate artists—Japan. 2. Artists—United States. 3. Art, American—
Japan. 4. Art, Modern—20th century—Japan. I. Verne, Michael, 1955— . II.
Title.
 N7355.4.F73 1997
 704.03'13052—dc21 97—10622
 CIP

Distributed by

USA	Japan	Southeast Asia
Charles E. Tuttle Co., Inc.	Tuttle Shokai Inc.	Berkeley Books Pte. Ltd.
RR 1 Box 231-5	1-21-13, Seki	5 Little Road #08-01
North Clarendon, VT 05759	Tama-ku, Kawasaki-shi	Singapore 536983
Tel.: (800) 526-2778	Kanagawa-ken, 214, Japan	Tel.: (65) 280-3320
Fax.: (800) FAX-TUTL	Tel.: (044) 833-0225	Fax.: (65) 280-6290
	Fax.: (044) 822-0413	

Credits and acknowledgments: Every effort has been made to obtain appropriate permissions and to credit copyright holders. Rights holders who wish to contact the publisher should communicate with the editorial offices of Tuttle Publishing, 153 Milk Street, Boston, Massachusetts 02109.

First edition
05 04 03 02 01 00 99 98 97 1 3 5 7 9 10 8 6 4 2

Design by Peter Blaiwas

Printed in Singapore

CONTENTS

n this day of hefty art historical scholarship, when you need a sumo wrestler to move a catalog or monograph from a bookshelf to your desk, it is refreshing to find a book like *Quiet Elegance* that you can still curl up with in a comfortable chair. The text and images introduce you to nine American artists who have lived or still live in Japan. Watercolorists, printmakers, and papermakers alike find inspiration in the urban and rural landscapes of the country where they traveled to study traditional art forms. Most are in their thirties and forties and are at varying stages in their careers. They are all risk takers, letting intuition lead them to personal discoveries and creative growth.

Quiet Elegance introduces these artists for the first time to Western audiences. Although they are well known in Japan, they have been overlooked by journalists and writers in the West. Generally books about contemporary artists working in Japan feature the new generations of Japanese artists, not Western artists. At first glance, their works look Japanese because they are infused with references to the past—lanterns, calligraphy, patterned silk kimonos, and atmospheric landscapes, the expected symbols of ukiyo-e prints and traditional painting. At closer look, however, their works are a synthesis of Eastern and Western sensitivities and styles. The unexpected emerges from the expected.

One of the book's greatest virtues is that it is not written by an art historian. Most books about artists and their works begin with for-malistic analyses of the images, identifying subjects and styles and their significance within the framework of artistic traditions. Since most of the artists featured in this book are friends, traditional art historical thinking would place them in a school and search for similarities

FOREWORD

and differences among their works. The authors, however, provide intimate snapshots of the artists' lives along with their work, and then allow the reader to make connections, to find other meanings in their lives and art. By diverting from a standard model, the artists and their work are immediately accessible. The reader is inspired by their perseverance and patience, their successes and failures. So, curl up in your most comfortable chair. Let Michael Verne and Betsy Franco introduce you to nine of their favorite artist-friends.

Marjorie Williams
Division of Education and Public Programs
The Cleveland Museum of Art

近頃は，あらゆる場面で生活のテンポが速くなり，現代美術の多くも攻撃的な感覚を持つようになってきたが，私はここで9人のアメリカ人芸術家の目を通して日本文化についていささか紹介したいと思う．9人にはそれぞれ個人的に会ったのだが，「静かなる優雅さ」とでも表現すべき彼らの仕事に出会ったことの意味が大きい．

　クリーブランドのヴァーン日本美術館は1953年に設立され，以来，日本の伝統版画と現代版画を展示してきたが，1986年になって日本の版画，美術，文化に深く影響を受けたアメリカ人の作品をも含めることにした．彼らはいずれも京都や東京で成功しており，その作品は世界の主要美術館で収集の対象ともなっている．作品はいずれも東方のイメージと西方の自由な創造とが渾然一体となり，しかも安定と平和を象徴しており，90年代の美術世界の中でも独特の風格を保っている．

　本書のねらいは，それら作品を掲げるだけでなく，作者の日本における体験をも伝えようとすることにある．これまで，当美術館への来館者の大多数がはじめは作品の平和というテーマに感動しながらも，やがてその作者について知りたがるということに，私は気がついていた．来館者たちは，作者がどこで学んだのか，あるいは美術館にどれだけの作品が収蔵されているかということよりも，作者の気質，挫折，好み，嫌悪，願望などについて知りたがるのである．こうした実状に照らして，本書の文章はまず版画家や画家自身の主張を収めて，展示会における評価よりも作者自身の当初のねらいを掲げてみることにした．

　本書に採り上げた9人のアメリカ人は，才能に恵まれたことを別として，それぞれに非日常的な生活を体験し，また多くの人々が体験することのなかった冒険を経てきたのである．彼らはここに掲げたような作品を通して，東方と西方との間の踏み石を創り出したのであり，アメリカ的な角度から日本文化の深い感覚を具体化して見せたのである．

In these times, when life seems to have speeded up on many levels and where much of contemporary art has a combative feel, I invite you to learn a bit about the Japanese culture through the eyes of nine American artists, to meet them on a personal level, and most importantly, to take in the quiet elegance of their work.

The Verne Gallery of Japanese Art was established in 1953, and for many years we offered traditional and contemporary woodblock prints by Japanese artists. In 1986 our focus shifted to include the work of American artists who had been deeply influenced by a brief or lengthy exposure to Japanese art and culture. These artists are well established in Kyoto and Tokyo, and their art has been collected by many of the major museums in the world. Their work combines the imagery of the East and the creative freedom of the West in a way that conveys a feeling of serenity and peace, a rare quality in the art of the 1990s.

The purpose of this book is to present not only the work of these artists, but also their experiences in Japan. Over the years I have found that most of the visitors to the gallery respond initially to the subject matter of a piece of art, but then they want to know something about the artist. They don't want to hear exclusively about where that artist studied or how many museum collections his or her work is in, but rather about the artist's habits, frustrations, likes, dislikes, and aspirations. As a result, the stories that follow are told primarily in the voices of the printmakers and painters themselves, to provide a first-hand account, rather than a second-hand interpretation of events and feelings.

INTRODUCTION

Aside from being very talented, these nine Americans have led unusual lives and have taken risks that many people would never take. Through their work, they have created a stepping stone between East and West, and have provided an intimate glimpse of Japanese culture, seen from an American perspective.

Michael Verne

Daniel Kelly first telephoned my Cleveland gallery on a cold, snowy day in January 1986, as a winter storm howled outside the window. Daniel asked if I knew who he was, and I told him I was familiar with his work from several art catalogs. He agreed to rearrange his return trip to Japan to include a four-hour stopover in Cleveland.

The snow was falling heavily and the visibility was low by the time I reached the airport. Rather than battle the elements, Daniel and I found an empty gate and began lining up his prints along the large windows. We didn't realize that another flight had been scheduled for that particular gate until we turned around to find a crowd of nearly one hundred people watching us.

I was impressed by the images I saw that day, and I felt very comfortable with Daniel. His early prints reflected the landscape images of traditional Japan, using a wonderful blend of Eastern and Western techniques. I told him I was very interested in showing his work in the gallery. He, in turn, unconcerned about how his own sales might be affected, has generously introduced me to other American artists studying and living in Japan.

Over the ten years we've known each other, I have watched Daniel's images go through numerous transformations. I've come to realize that Daniel is a risk taker, both in his art and his life, and that he has seized many opportunities along the way to his success.

Daniel was born in Idaho Falls, Idaho, in 1947, and spent his childhood in Great Falls, Montana. His interest in art began at an early age. "From the first grade, I loved it," he says. "It's the love of art that makes a child a good artist or not. If you love it, it's easy."

There were no museums in Great Falls. His first exposure to art consisted of walking by the studio of C. M. Russell, the famous cowboy artist, and seeing the brushes and art materials in the display case. Some of Russell's early art in the local children's library was a bit "clunky" in Daniel's estimation, and he thought to himself, "I can do this. Art isn't this big holy thing."

DANIEL KELLY

At the lunch counter in the local community center, Daniel remembers staring at a traveling show of several large expressionist paintings that he thinks were probably the works of Franz Kline. This served as his introduction to contemporary art.

Despite Daniel's interests, none of the Catholic colleges he attended offered a degree in art, and he majored in psychology instead. It wasn't until graduate school at Oregon's Portland State University that he became involved in ceramics and glass blowing. After moving to San Francisco and setting up a flat-glass factory, an advertisement in City Lights Bookstore led him to art classes at Morton Levin's Graphic Arts Workshop. Although many art schools were more conceptually oriented at the time, Daniel says, "Mort was very severe when I got there." Daniel was taught art in the traditional way, through such disciplines as color theory and perspective.

After a year of intense work with Mort on Saturdays and evenings, Daniel met a Japanese woman from Kyoto, who invited him to visit her in Japan. He was interested in the woman, and was intrigued by the idea of traveling for a month with a native of the

country. At Mort's suggestion, Daniel decided to learn something about Japanese art. With little money in his pocket, he headed for the bookstore.

"I went back to City Lights," Daniel says. "I couldn't afford the expensive art books, except for a little paperback for $1.95 by Tokuriki. I could afford that. In the back of the book it said, 'If the reader of this book has a chance to visit Kyoto, feel free to contact the author.'" Daniel thought to himself, "I'm going to Kyoto. I'm going to see Tokuriki!"

Coincidentally, his Japanese girlfriend had once interviewed this famous traditional woodblock printer, and she took Daniel to Tokuriki's home soon after they arrived in Kyoto. "At that point, Tokuriki was about eighty years old," Daniel says. "After seeing my slides, he asked me if I'd like to study with him. He said it would take five to seven years, I would have lunchtimes off, and to be there at eight o'clock in the morning. I thought, This is a great opportunity. I'll take it as far as I can."

Tokuriki showed Daniel the tiny rooms where the carving and printing took place. There were traditional woodblock-printing benches on the floor. Tokuriki pointed to his own bench and told Daniel, "You can work here."

The first woodblock Daniel made was black and white. During the process, he had to work on his knees. Since his arms were longer than Tokuriki's, Daniel moved some of the materials around slightly, in order to make himself more comfortable. A Japanese woman appeared immediately, saying, *"Dame!"* which means bad. She proceeded to put everything back where it had been.

Daniel was a bit bewildered by this, until not long after, while thumbing through an art book from the Edo period, he saw a print of a woodblock printer's bench. Everything was in exactly the same position as the materials on Tokuriki's bench.

Daniel reflects on this experience: "Tokuriki is still alive and is ninety-five, or maybe ninety-six. He's a dinosaur. The man he studied woodblock printing from was a printer of Hiroshige. It's a really quick, small world and how little it's changed!

"Tokuriki introduced me generously to everything in the woodblock world. I still go back to pay my respects. I'm still his *deshi*, his apprentice—it's a lifelong thing."

Daniel says that Tokuriki taught him some important lessons about issues other than technique. "Tokuriki said that, during the Edo period, a woodblock print was the same price as a bowl of noodles. He advised me not to be expensive, not to be elitist. He said it's for the public because it's printed art. Make it accessible to the world."

Daniel's first show, at a Takashimaya department store, was in the summer of 1981. Soon after, he submitted a print entitled "Rolling In" to the College Women's Association of Japan (CWAJ). This woodblock, showing girls riding bicycles, was his first print to be released publicly and it was an edition of one hundred. Daniel attended the opening of the CWAJ print show, one of the most important print shows in Tokyo. In one weekend, all one hundred of his prints were sold out! Daniel was taken by such complete surprise, he only had one or two copies of the print left for himself. Shortly after the show, he was informed that the same print had sold at auction for five times the original price. The artist Sarah Brayer, who was with him at the time remarked, "You're not even dead yet!"

Daniel continued to make more landscape and figurative prints. One print following the tradition of Tokuriki was "Children's Parade," showing a teacher and a row of children walking in the mist.

"When the Met collected that one, the curator told me that was the first woodblock print they'd added to their Japanese collection since the twenties," Daniel says. "I began to realize maybe this was a good idea."

Daniel could easily have stayed with the traditional images of scenery near his Kyoto home and studio. Everyone loved his prints. But instead he continued to experiment with different mediums and different styles of printmaking and painting. He decided that "the basis of a good print is a good image, and the way to that is through drawing and painting." He had always done sketches, even of the people who came into his studio. In fact, he compares his quick sketches to a musician practicing scales. But he was led at that time to pursue watercolors with Brian Williams, who was already established as a watercolorist.

"Brian and I started painting landscapes together," Daniel says. "My purpose was to learn about natural color. Mort had taught me about color theory, but I didn't know how to paint a leaf. We painted landscapes a lot outdoors. We pushed each other, supported each other. We made a rule one day—throw away the pencils. He and I revere that moment. That was a turning point in our growth as painters."

Daniel describes his relationship with Brian further: "Brian and I will die telling each other every secret because we grew up together in our careers. We were both trying to figure it out. We talk about how art is made all the time."

Daniel created landscape woodblock prints from his watercolors and also began painting still lifes.

"In the Gion Festival in Kyoto," Daniel says, "they hang out paper lanterns with an umbrella over them to protect them from the rain. Brian and I both painted a paper lantern. In a way, looking under that umbrella reminded me of looking up someone's dress." From that experience at the festival, Daniel drifted out of landscape and began painting lanterns. He became intrigued with these voluminous, hollow objects, and proceeded to eliminate more and more of the landscape background, focusing on the "big, fat lanterns" and the spaces between them.

About the same time, in the early 1980s, he felt compelled to go to New York to gain some exposure to contemporary art. He didn't want to be "just another landscape watercolorist." He was also concerned that the steps of woodblock printing had a tendency to "stiffen the image. It lost some of its fluid quality," Daniel explains. "On the other hand, lithography directly translates the drawn image. That appealed to me a great deal."

Consequently, Daniel's first lantern print was a lithograph. He worked directly with a printer who "made sure I didn't screw up." That lantern print was as successful as "Rolling In" had been, selling out the first weekend at CWAJ. Another print, "Buttercups," was also a big hit. It depicted children carrying the bright yellow umbrellas that make them visible to cars. CWAJ told Daniel that, at that point, he was the best-selling artist they had ever had.

Surprised again by his success, Daniel continued doing lantern lithographs. He began moving in closer to the image and incorporating other elements with the lanterns. In the manner of Franz Kline, whose work he had seen in Great Falls as a child, Daniel began "slashing in black" to incorporate expressive brushwork in the background of the lanterns. He also bought antique books in Kyoto, tore them up, and glued them onto the image.

"From the beginning, I decided I admire people who overcome obstacles," Daniel says. "In the printmaking process, I wanted to use a Dutch linen paper. The printer said, 'This won't print.' This intrigued me all the more. I started collaging a variety of papers underneath the image. Where the paper doesn't print, the paper expresses itself. It talks about itself. That interested me—more than looking like a photograph. I think the world likes this about my work."

Continuing to explore different types of subject matter, Daniel made a portrait of his father—a lithograph—that was intended as a gift on an upcoming trip to the United

States. He brought one copy of the print with him to New York, and on the advice of a friend took his work to the Museum of Modern Art (MOMA), where he was given the standard sheet of paper directing him not to expect any comments or criticism from the staff. He sat for an hour before the curator came out. The print portfolio was taken from him, and he waited for another hour. Then he was asked to come to the back room, and all the prints except the portrait of his father were returned to him. "We really like this print. Could we have it?" they asked.

"No, you can't," Daniel told them.

He explained that it was the only print he had. They insisted that he send a copy as soon as he had printed it, and they sent a check as incentive.

"That made me think," Daniel said. "Why were they interested in this picture that was a fairly loose portrait of my dad? It didn't look like a lithograph—it's a painted lithograph [tusche-wash]. A lot of lithographs are drawn with a crayon. Also, it's somewhat abstract."

Other museums were beginning to recognize Daniel's talents as well. His father's portrait was collected by the New York Public Library and the Brooklyn Museum. The Metropolitan Museum of Art has one of his traditional images and a lantern print. The Smithsonian Institution and the Los Angeles County, New South Wales, British, and Cleveland museums have also collected his work.

Encouraged by MOMA's purchase, Daniel began an extensive series of portraits depicting family members and historical figures. Around the same time, he embarked on a series of large lithographs of New York, where he spent nearly four months of the year, and of Kyoto, where he resides. "Snowflakes I" and "Snowflakes II" show the contrast between the two cities. The large buildings of New York are contrasted with the rice fields of rural Kyoto. These two magnificent lithographs are examples of his finest work from this period.

Ever changing, Daniel moved into cement-block prints with a series entitled "Cream of the Crop." His father was a tile and marble contractor and as a boy Daniel had helped build swimming pools in the summers. Now he incorporated his knowledge of cement into his art. "They are made of sheets of plywood coated with cement," he explains. "I can carve down into the wood. I had some concrete relief on some of the woodblock prints, going back to one of the very first ones. I'd done that just for texture, like for the grasses. With 'Strawberries,' I made the whole print out of concrete relief. This is not something most people do, because they don't have the background in tile and marble."

One of Daniel's latest prints, "The Secret," is a combination of cement block, lithography, and handcoloring. It measures approximately six feet long by fourteen inches high. All of Daniel's prints from the last few years have some element of mixed media, as this one does. "You mix whatever you want. There's no purity in my thinking," Daniel says.

Most of his lithographs have woodblock color plates on them, and many of his woodblocks include some lithography. He has collaged antique Japanese paper and gold leaf, and has used handcoloring extensively. He is certainly not daunted by a challenge.

"I get this idea and I want to see this thing. I really don't like it if I have a concept—it doesn't exist yet—and people say you're going to run into this and that problem. I want to slap those people out of my way. If there's a problem, I dig deeper. Painting is like war. I get in there and battle and fight. It's either me or the painting. One of us will win."

I enjoy working with Daniel because it's exciting and fun. I've come to enjoy his disorganized approach, which is so different from my own. Just to gather some of the information about him for this book, I had to call dozens of times to try to capture him in three different cities, in two different countries—between his dental appointments, his

drives to the airport to pick up luggage he had stored, and his visits to friends and relatives.

I got an even closer look at Daniel's lifestyle while staying with him in his traditional Japanese home, which is outfitted with the latest technology. One of the most memorable parts of the visit for me was a long, hot bath in the tub that Daniel designed and built. I walked along the black stones strategically placed outside the tub to imitate a riverbed. After opening the sliding window, I laid back in the water to view the full moon and listen to the crickets in the Kyoto night air. The next day, I was amazed when all of the friends who dropped by Daniel's house took turns taking a bath!

Over the years, I've found that he is the type of person who gets things done at his own pace, in his own way. It has been very satisfying for me to watch the growth of an artist who does not produce his work for the market, but rather according to what he wants to say.

From the beginning, I've also admired his unflinching trust in me. Even though some galleries had taken advantage of his trusting nature, he never passed on that mistrust to me. At the time I met Daniel, the Verne Gallery was very small. We had not yet done the important works-on-paper shows, and we were not located in a major city. Daniel was very laid back and didn't expect instant results.

I commissioned a woodblock print from Daniel in 1991, the year he married his wife Junko, a wonderful person who is very easy and comfortable with everyone. When Daniel showed his print "Junko" to his woodblock teacher, Tokuriki brought out prints of Japanese *bijin* (beauties) by such artists as Onchi, Goyo, and Shinsui. He said he felt Daniel should compare his creation to these masterpieces.

That same year, I introduced Daniel's work at the Works on Paper show at the Armory in New York. Many of the most important galleries in the world are invited to do the show each year. Most of the galleries are from such places as New York, Paris, London, and Munich. People are always pleasantly surprised to see a small gallery from Cleveland. Each year at the show, I watch people literally stop in the aisle to view one of Daniel's creations. Even in New York, they have never seen anything like it.

This reaction is partially attributable to the fact that Daniel's work has an immediacy about it, no matter the style or medium. For this, Daniel credits his *sensei*, Tokuriki.

"I studied sumi-e [black-ink painting] from Tokuriki, and that was philosophically important. He would kneel down and paint a bamboo. He'd move aside and tell me to paint it. He might make a comment or two. If I made a correction, he said, 'Don't correct it, do it again.' That immediate touch—the moment you're doing it—is important. Like throwing away the pencil—that came from sumi-e."

Through it all, Daniel remains down-to-earth about his success: "I'm less romantic about art. I don't think you're born with a talent, that you have it or you don't. Through hard work and training you become who you are."

At the same time, Joshua Rome's description of his friend Daniel is very apt: "Daniel is definitely a real artist. He has vision, knowledge, and skill, and very few artists have all three. He really enjoys what he does—he gets this shit-eating grin [*ninmarisuru*] on his face. His stuff's alive!"

ダニエル・ケリーはアイダホ州アイダホ・フォールズに生まれた．彼は18歳の時に日本に旅立つ前に，1.95ドルで1冊の美術の本を買った．それだけしか買えなかったのである．徳力富吉郎という美術家が書いたこの小さな本の裏表紙には，紹介文が書いてあって，「もし，この本の読者が京都を訪れる機会があれば，著者に自由に会うことができる」とあった．結局，ダニエルは徳力の弟子となり，後にその作品はメトロポリタン美術館，ニューヨーク現代美術館，大英博物館，スミソニアン協会などに収蔵されることとなった．ダニエルはスタイルを変え続けていくというおもしろい作家である．ここ数年の彼の版画はいずれもリトグラフ，セメント版，手彩色といった要素を複合的に用いている．彼は自己の製作過程について，「私は構想というものを持つことが好きではないのです．そんなものはまだないし．だから，あれこれ走り回っていると言われます．けれど，そういう人を批判したいと思います．もし問題があれば，私は深く掘り下げてみたいと思うのです．絵を描くことは戦争に似ています．私はその中に跳び込んで戦いました．それが私でもあり，絵でもあるわけで，どちらか一方が勝利を収めることになるでしょう」と語っている．

ダニエル・ケリー「淡雪I」（リトグラフ，Ed.7，1984年）
ダニエル・ケリー「淡雪II」（リトグラフ，Ed.7，1984年）
ダニエル・ケリー「雨の中を行く」（水彩，1984年）
ダニエル・ケリー「京都からの手紙」（水彩，シーヌ・コレ，1995年）
ダニエル・ケリー「子供たちが行く」（木版，A.P. 8/30，1981年）
ダニエル・ケリー「少女たち」（木版，A.P. 1/25，1982年）
ダニエル・ケリー「秘密」（セメント版，木版，リトグラフ，手彩色，Ed.32，1994年）
ダニエル・ケリー「直進」（木版，リトグラフ，手彩色，Ed.32，1994年）
ダニエル・ケリー「順子」（木版，Ed.50，1989年）
ダニエル・ケリー　版木
ダニエル・ケリー「苺」（木版，リトグラフ，セメント版，手彩色，Ed.20，1990年）
ダニエル・ケリー「古代青」（水彩，1996年）

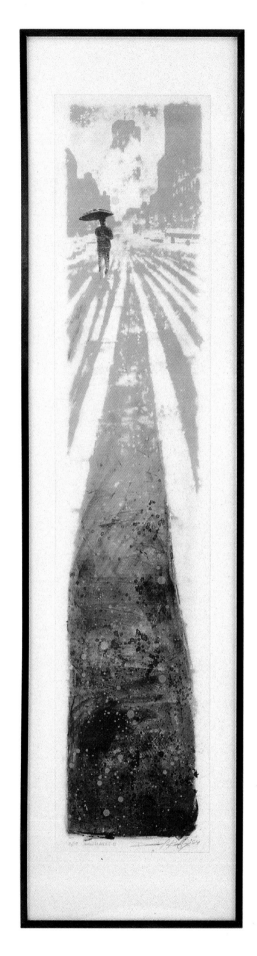

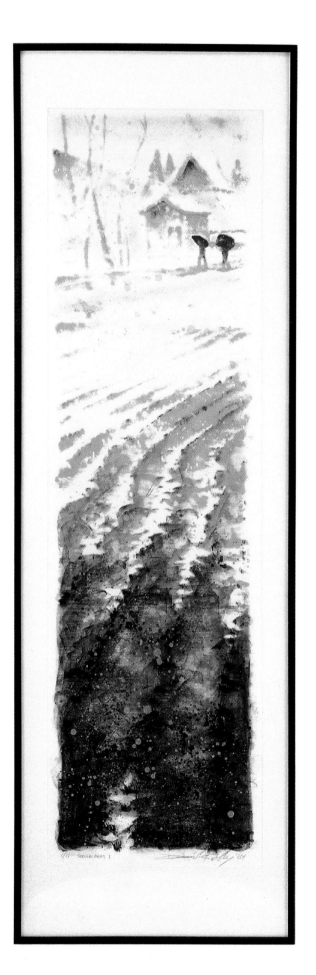

Daniel Kelly. *Snowflakes I*. Lithograph. Ed. 7. 1984

Daniel Kelly. *Snowflakes II*. Lithograph. Ed. 7. 1984

Daniel Kelly. *Walking in the Rain.* Watercolor. 1984

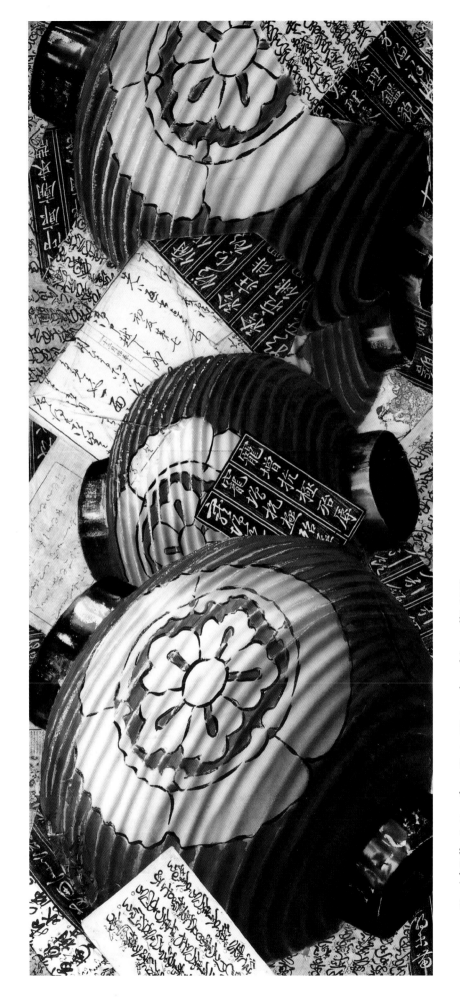

Daniel Kelly. *Letters from Kyoto*. Watercolor, chine collé. 1995

Daniel Kelly. *Children's Parade.* Woodblock print. A.P. 8/30. 1981

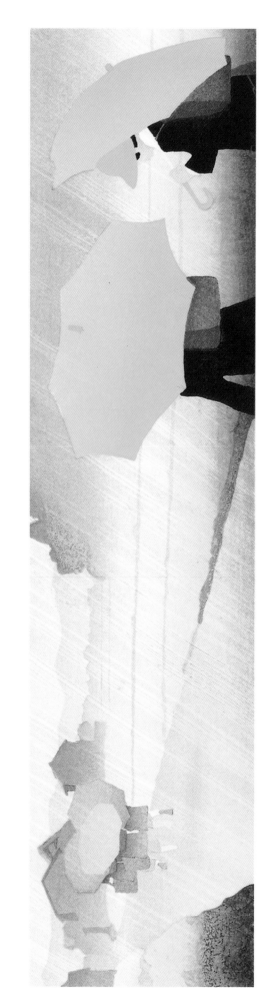

Daniel Kelly. *Buttercups.* Woodblock print. A.P. 1/25. 1982

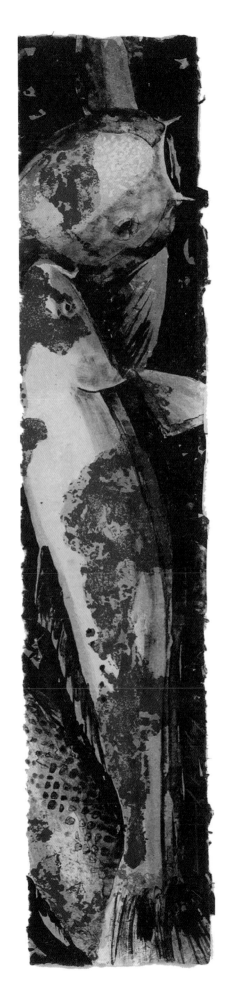

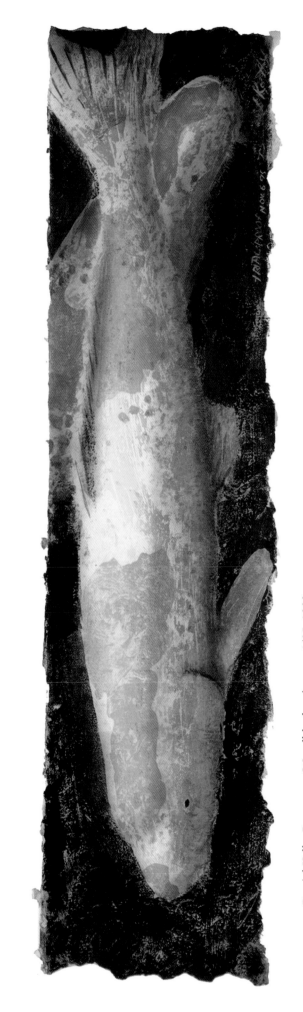

Daniel Kelly. *Children's Parade*. Woodblock print. A.P. 8/30. 1981

Daniel Kelly. *Buttercups*. Woodblock print. A.P. 1/25. 1982

11

Daniel Kelly. *Junko*. Woodblock print.
Ed. 50. 1989

Junko. Keyblock.

Daniel Kelly. *Strawberries*. Woodblock, lithograph, cement block, handcoloring. Ed. 20. 1990

Daniel Kelly. *Ancient Blue.* Watercolor. 1996

From the start, Karyn Young's work made me laugh. The first piece I received was a whimsical print called "Sea Bound." Goldfish, the one fish the Japanese don't eat, are shown swimming past a sushi menu waving their fins. The menu, which Karyn wrote in Japanese characters, presents the names of the fish that can be ordered. We had great success with this print, selling almost twenty-five of the edition.

The story of how Karyn developed as an artist, from her weaving days to the time I met her, reminds me of one of her collages—colorful, many-layered, rich, spontaneous, and whimsical. Karyn was born in Montréal, Québec, in Canada. At Goddard College in Vermont, she majored in weaving and textile design. "I studied weaving, spinning, and natural dyeing, and that evolved into sculptural fiber art," Karyn explains.

After college, Karyn's apprenticeship to a San Francisco weaver, Carol Rae, lead to the opening of her own shop, Woven Threadworks, at the age of twenty-one. "I'd never had a business course in my life," she says. "I had this store and a big studio in China Basin. After a year and a half, I realized I wasn't cut out for the retail business."

In 1980, Karyn made the decision to sell her weaving business. At about the same time, her mentor traveled to Japan for a special month-long intensive program. "Carol took this course in Japanese traditional arts at Oomoto," Karyn says. "They teach tea ceremony, flower arranging, Noh theater, sumi-e brush painting. You wear a kimono every day. Carol insisted that before doing anything else, I had to take this course."

Based on Carol's recommendation, Karyn proceeded to convince her now ex-husband Peter to quit his job. Their plan was to participate in the program at Oomoto and then travel to neighboring Asian countries that were less expensive. They had no intention of staying in Japan. "We got all our vaccinations for India. I had my *Southeast Asia on a Shoestring* book. Then we went to the course at Oomoto, and it was a life-altering experience," Karyn says. Nepal was to be their next stop after Oomoto, but a fellow classmate who was moving out of his small home suggested they rent it as a base of travel. They agreed.

KARYN YOUNG

"We ended up getting to know our neighbors," Karyn says. "Then two birds flew onto my shoulders when we were out hiking, and I took them home. One died, but we bought a cage for the other one, and now we had a bird. Some neighbors gave us a teapot, another gave us a futon. Someone asked if I could teach English to her daughter. Before we knew it, both of us had jobs teaching English. We thought, We have a place to live, we have a teapot, a futon. We should stay."

It was almost December at that point. Karyn and Peter had already missed trekking season in Nepal and people were saying, "You can't leave now. You haven't seen Oshogatsu, Japanese New Year." As spring approached, their Japanese friends said, "You can't leave without seeing the cherry blossoms."

Almost a year had gone by. Karyn decided to take advantage of being in Japan by studying Japanese weaving and tea ceremony. She found a teacher who taught Kasuri weaving, in which you dye the warp before weaving into it. Once she felt comfortable

with the method, some conflict developed with her teacher, mainly because Karyn had been a professional weaver and wanted to try out her own ideas, which weren't always in sync with the teacher's.

Karyn decided to drop weaving and join a friend who was involved in kimono stencil dyeing. The particular technique, *bingata,* is from Okinawa. Her teacher was a student of Keisuke Serizawa, who was designated a Living National Art Treasure by the Japanese government. (Coincidentally, the Verne Gallery was the exclusive representative of Serizawa's hand stencil–dyed prints in the United States.)

"I loved it. It was colorful," Karyn says. "I decided that for me to come into a Japanese traditional art as a beginner was much easier than to come in as a weaver, where I had my own ideas—which doesn't work when you're a student of a Japanese teacher."

She started with little placemats and evolved into kimonos and obis (sashes). The technique, which is done with a resist paste somewhat like batik, is very labor intensive. It involves making a little sample, soaking the stencil paper in persimmon juice for a couple of weeks, cutting the stencils, doing the resist process, printing the color, and making the kimono. In all, it takes about five months to complete one kimono.

"The process [*bingata*] was so long, it started to make me a little crazy," Karyn says. "I'd start something. After a couple weeks, I already had fifteen new ideas I wanted to try out, but I still had five months to go on the first kimono."

As a part of the *bingata* process, the teacher would pick the colors that the students would use on their kimonos. After two or three years of this, Karyn felt that she was ready to pick her own colors. "It caused a scandal in the class," Karyn says. "I was the newest student and the youngest and the only foreigner. The other women thought, You have some nerve. We've been in this class for twenty-one years."

Karyn made a few kimonos picking her own colors, but she was having doubts about her future. She had been studying the tea ceremony, another intensive course, simultaneously. After seven years, her teacher said, "Just another ten years and you'll be really good." She laughs when she says, "I could have been a rocket scientist for NASA by then."

She began to wonder how a person like her, with a spontaneous and energetic personality, had ended up in so many arts that required great patience. On top of that, her study of the Japanese arts was still more like a hobby, with no particular goal in mind.

At a New Years party, things began to shift. She was celebrating with a group of women artists, who were all eating and drinking sake. It was two in the morning when the Japanese women decided it was time to do *kakizome,* the first calligraphy of the year. They explained that the first time you write with a brush and ink in the new year has great significance.

"I was the only foreigner," Karyn says. "They got out paper and brushes and ink stones. They all in turn wrote the poem 'Iroha,' which is a famous poem that includes all the *hiragana* characters of the alphabet. It's a beautiful poem about a Buddhist priest who goes into the mountains." "Of course I had no idea how to do it and I was tipsy anyway. Kayo, whom I didn't know, put her hand over my hand, and she wrote out the entire thing with me."

It was delightful for Karyn, and she was invited to Kayo's calligraphy studio.

"Until then, calligraphy wasn't something I'd planned on studying. It seemed too austere. Even though there was a part of me that had developed an understanding of *shibui*—understated elegant simplicity—it took me a number of years to appreciate the simplicity of black ink on paper."

Karyn felt such a fondness for Kayo, she decided to go to her studio the following Sunday, "more to see her again, than to do an in-depth study of *shodo*—the way of the brush." Karyn arrived with a box of sweets, and that was the beginning of her closest friendship in Japan. Kayo was like Karyn's Japanese mother and taught her about the old side of Japan. The relationship was significant for Kayo as well, because Karyn was the first foreigner with whom she could communicate.

The study of calligraphy was a very freeing experience for Karyn. After years of weaving, *bingata*, and tea ceremony, it seemed refreshingly direct. Eventually, Karyn was at the stage where she would take home a poem and copy it one hundred times. For this type of assignment, she found it very difficult to get every character correct in one version.

"I had the great idea to show Kayo that I could do all the characters correctly," Karyn says. "So I did it one hundred times, then I looked at all my papers and cut out the best characters from each one and glued the whole thing together. Kayo thought this was the most hysterical thing she'd ever seen in her life. Only a foreigner would come up with this idea. This was my first collage."

Kayo was different in this way from Karyn's other teachers. She encouraged Karyn's creativity and individuality, and Karyn continued to study with her.

That first collage led to others. Karyn started to use her old calligraphy papers and the stencils from her *bingata* days. Someone had also given her an airbrush.

"I'd take a kimono stencil and put it on top of the paper I'd done my calligraphy on and use an airbrush and spray through the pattern. The pattern would come out on top of my calligraphy, making an arty kind of piece. Using all the skills I had been learning in a traditional way, I finally felt confident enough to begin expressing what they meant to me."

Karyn and Peter had moved to a larger house, which they couldn't afford without roommates, one of whom was a Japanese fortune teller and the other a French chef. When the fortune teller moved out, her little room became Karyn's studio. At this point, to make her collages, Karyn would rip up her calligraphy papers—there were hundreds lying around—use her *bingata* stencils, and add little scraps of kimono fabric she had left over.

One of Peter's English students, who coincidentally owned an art gallery, found Karyn's creations unique and interesting and asked if she'd like to do a show. Karyn's response was, "Me have a show?" She worked days and nights to prepare for it, and for the first time in her life, had her pieces framed. The show received media attention because the work incorporated traditional Japanese elements in a unique format. And then the week-long show sold out. Karyn and everyone else involved were stunned.

"I began to build confidence. This whole time I really had not considered myself an artist. I had considered myself a weaver, a craftsperson—a fiddler-arounder, an arranger. I'd always had a need to keep my hands busy, which is the reason I'd always been attracted to the craft world. Before then [the art show], I would never have had the presumptuousness to say I was an artist."

After moving to a bigger studio, Karyn began to work in a larger format. She still loved kimonos, textiles, and fabrics. Having worked with real kimonos and having seen many exhibitions of hung kimonos, Karyn was inspired to start a series on the theme of kimonos. These have become her signature pieces.

"I had the kimono, which was a very balanced, symmetrical shape, and I started working within the shape of it," Karyn says.

When Daniel Kelly saw her work, he said it would translate very well into lithography.

"That was the beginning of learning printmaking. Even as determined as I am, I've

never been aggressive about going after things that I want. Things have to come near and then I nod my head at them. So when Daniel said 'You should try to make prints,' I thought that was a good idea," Karyn explains.

Karyn had done a little printmaking in college, but Daniel generously taught her how to make the plates and introduced her to his master printer in Tokyo. Her first print, "Kimono Sunrise," was purchased by the British Museum. It included calligraphy and chine collé, a combination of collage and printing. Nowadays, the kimono prints she creates usually include black-and-white silkscreens of old woodblock prints, which she colors in with lithographic inks.

At the time of her first kimono print, however, she realized that she needed to have more than one print in order to approach galleries. She became intrigued with teapots—she collected them, received them as gifts, and loved drinking tea. "Tea for Two," and "Tea for Three" with one extra cup, were part of a series on teapots. These prints reflect Karyn's understanding of the tea ceremony and the humor found in the rigidity of this Japanese ritual.

From teapots, she moved on to food. "Itadakimasu" is a silkscreen and chine collé print. Saying *itadakimasu* before eating means you're acknowledging receiving the food from a higher source—you're humbling yourself before the giver. Karyn's print captures the feeling of appreciation for the food the Japanese eat and the beauty of how it is displayed.

A trip to a fishing village with Kayo and trips to the Tokyo fish market at four in the morning helped trigger Karyn's fish series. It didn't hurt that she was seeing fish everywhere in Japan as a design element—on fish-shaped plates, as fish-shaped sweets, and on Boys' Day banners. Along with "Sea Bound," other prints on the fish theme are "Swimming Upstream" and "Fish Gotta Swim." The latter was quite complicated to complete because it involved stencil dyeing, silkscreen printing, lithography, and chine collé.

"I like the kimono and the fish shape," Karyn says. "I like to work inside a form. I'm always looking for things to give me borders somehow."

I was introduced to Karyn by Daniel Kelly. Her work was more elegant than the other work I'd been selecting. For my collectors who were not interested in landscapes or subdued colors, Karyn's work was very appealing. She was using bright colors to depict kimonos and traditional Japanese ceremonies, in a whimsical manner. In her work, the blending of colors and design is that of a weaver and kimono designer, while the use of space and subject matter is that of a Japanese printmaker. I find that people who see her work either find it sophisticated and elegant or quietly funny.

In 1990, we had our first one-woman show for Karyn at the gallery. Although Karyn and I had not met in person before the show, I felt as though I had grown up with her. She had a wonderful sense of humor that came through in her work and her personality. The feature of the show was to be a large hand stencil–dyed kimono design. One week before the show, we received a telephone call from the Texas Rangers baseball club. The caller stated that our package was coming from a very important player on the Detroit Tigers. We were baffled. I called Karyn that night, and she explained that she had done a special commission for a ballplayer's wife when he was playing for a Japanese baseball team. The finished work did not match the wife's noritake dishes, so she rejected it. The next day a huge crate arrived from the Rangers. Enclosed was a magnificent hand stencil–dyed wedding-kimono print. The show was ready to open.

We displayed the print prominently on opening night. Karyn's parents flew in from

Canada, and the show was a great success. Over the next few years, Karyn continued to send me her whimsical images and had numerous shows, both in Japan and the United States.

In 1994, after fourteen years in Japan, Karyn returned to the San Francisco area. At this point, she is still questioning what she wants to express visually, but I am sure the Japanese influence will not disappear from her work. She describes her body of work from her years in Japan this way: "When I do art, it enables me to express the experiences in my life up to now and synthesize them in a visual form. My work is very much my experience of being a Westerner who has spent much of my life in an Eastern culture. My prints are so much a part of the traditional and the modern me."

カナダのモントリオールで生まれたカリン・ヤングは，もともとはテキスタイル・デザイナーであり，織り手でもあった．1980年に日本へ行ったのだが，そのまま14年間も滞在することになるとは本人も思っていなかった．日本滞在中に，彼女は日本の文化に心酔するようになり，絣織り，捺染，水墨画，書道，版画などを学んだ．何年も経ってから，彼女は自分のように自発的活力に満ちた人間が，最終的になぜ多くの忍耐を要する芸術活動の道に就いてしまったのか考えるようになった．そうして，学んできた伝統的な技法を用いて，奇抜で優雅なコラージュを創造する方法を見出したのである．彼女はこの方法で日本で製作した自身の作品について，次のように述べている．「私が製作活動をするとき，現在までの自分の生活の体験をヴィジュアルな形式で表現することが可能になるのです．私の作品は，東方文化の中で生活の多くを費やしてきた一西洋人としての私の体験そのものなのです．私の版画は伝統的な自分と現代的な自分の双方すべてを表現しています」．

カリン・ヤング「鶴」（パステル，アクリル，コラージュ，1996年）
カリン・ヤング「海へ行く」（シルクスクリーン，Ed.70，1989年）
カリン・ヤング「お茶」（パステル，アクリル，コラージュ，1996年）
カリン・ヤング「3人でお茶」（木版，リトグラフ，シーヌ・コレ，Ed.35，1993年）
カリン・ヤング「いただきます」（木版，リトグラフ，シーヌ・コレ，Ed.35，1993年）
カリン・ヤング「魚が泳ぐ」（型染め，シルクスクリーン，リトグラフ，シーヌ・コレ，Ed.50，1993年）
カリン・ヤング「春」（シルクスクリーン，シーヌ・コレ，型染め，手彩色，Ed.48，1991年）

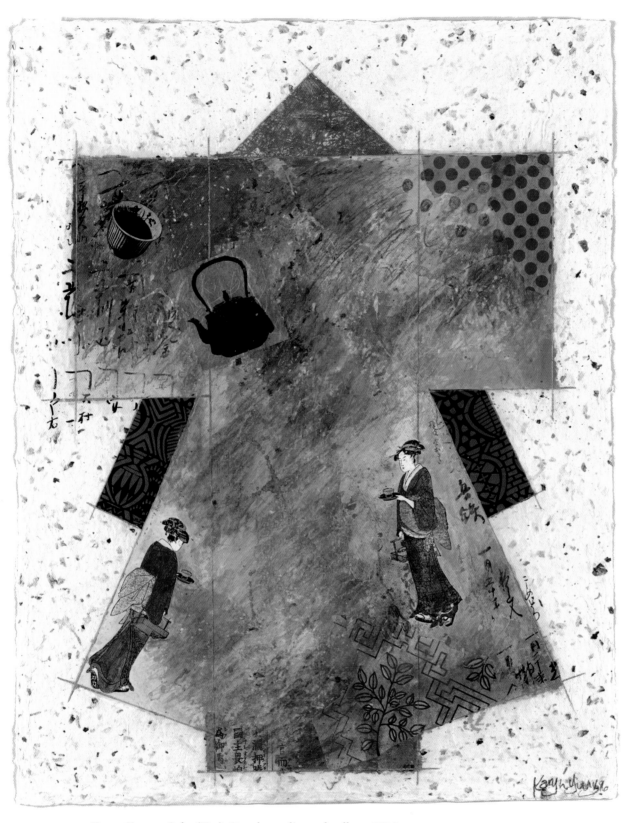

Karyn Young. *Ocha* (Tea). Pastel, acrylic, and collage. 1996

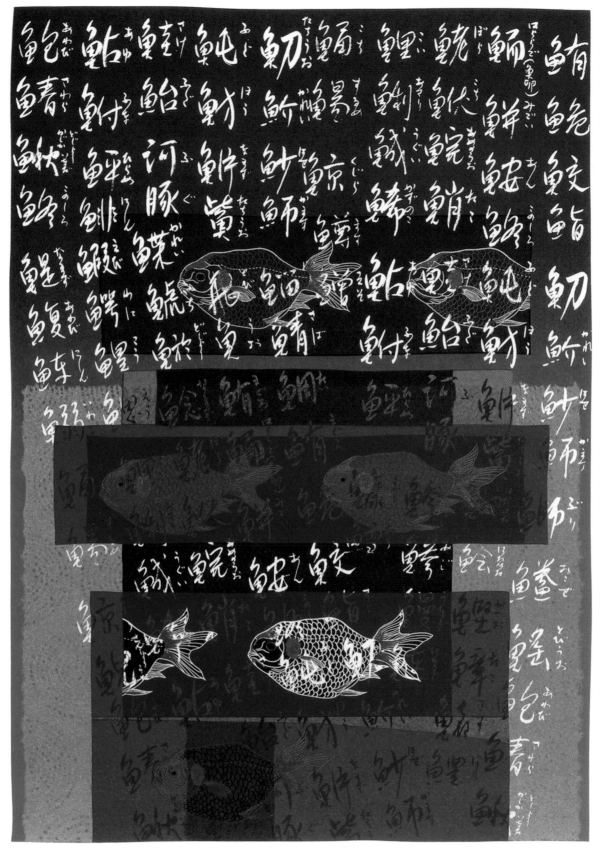

Karyn Young. *Sea Bound.* Silkscreen print. Ed. 70. 1989.

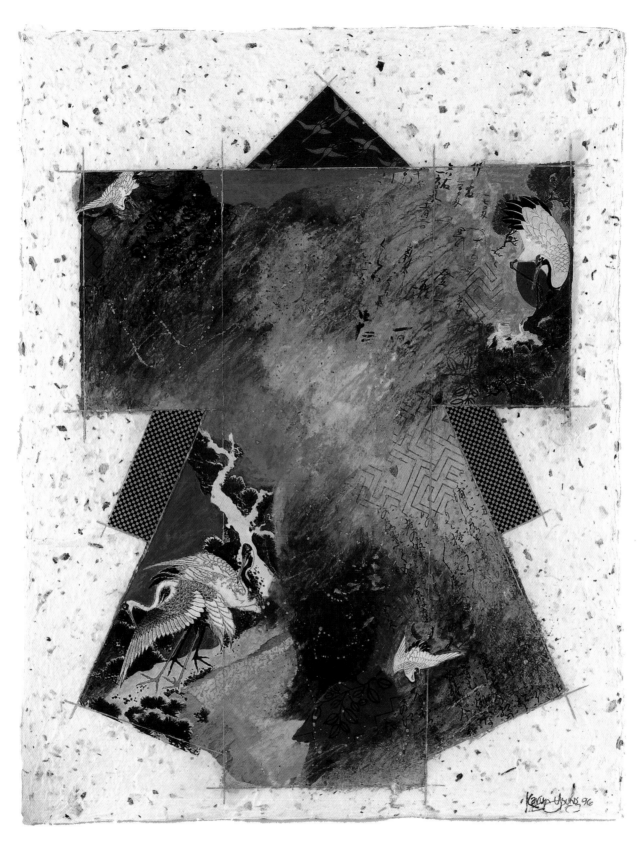

Karyn Young. *Tsuru* (Crane). Pastel, acrylic, and collage. 1996

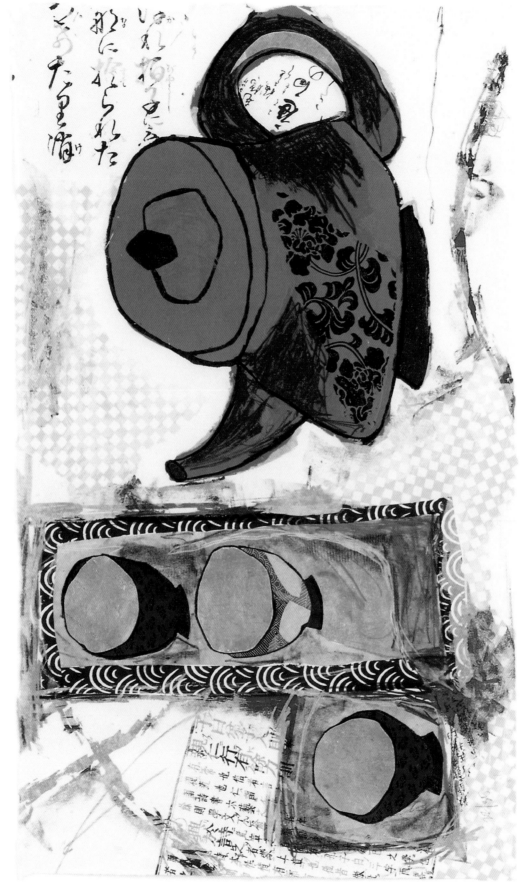

Karyn Young. *Tea for Three*. Woodblock, lithograph, and chine collé. Ed. 35. 1993

24

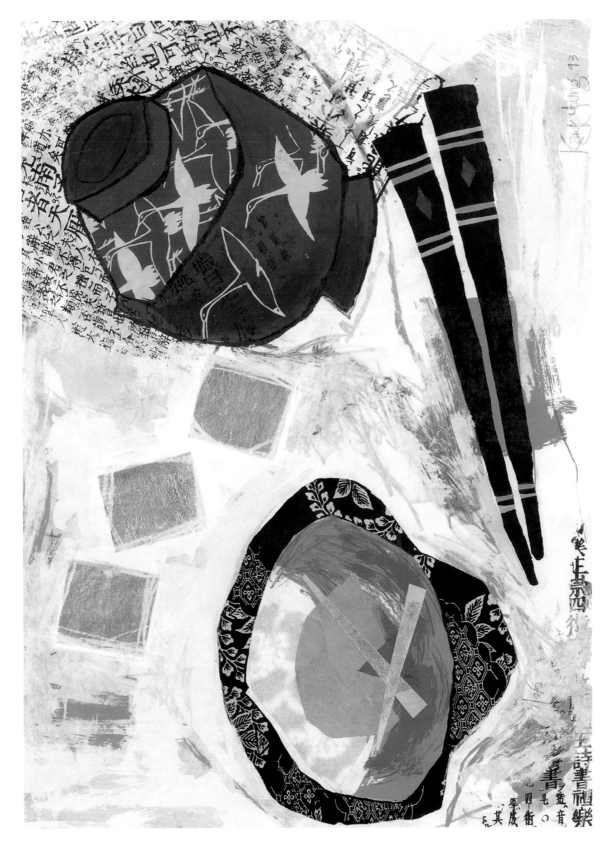

Karyn Young. *Itadakimasu.* Woodblock, lithograph, and chine collé. Ed. 35. 1993

25

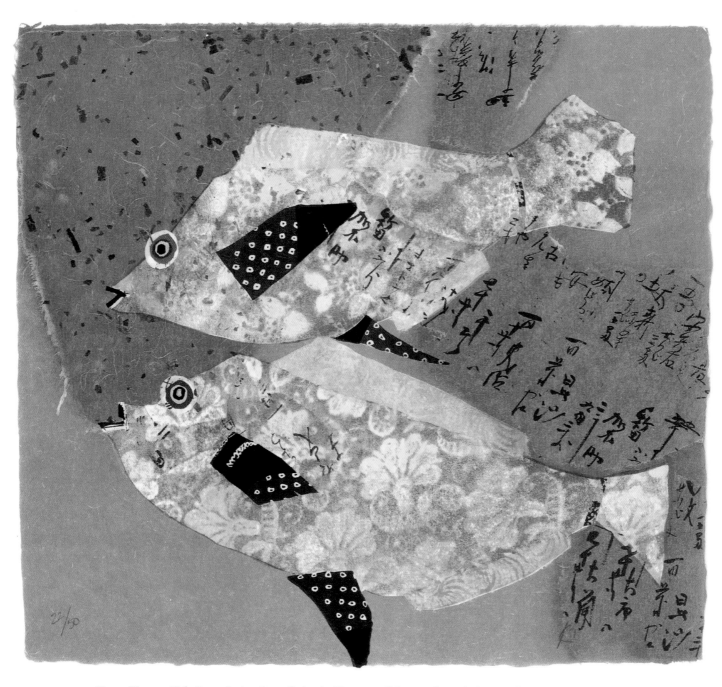

Karyn Young. *Fish Gotta Swim.* Stencil-dyed, silkscreen, lithograph, and chine collé. Ed. 50. 1993.

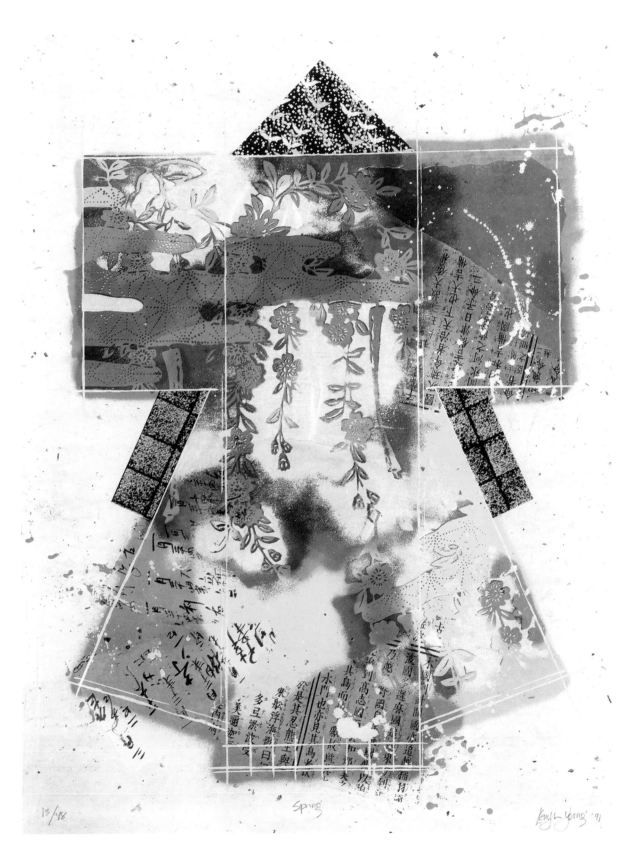

13/48 *Spring* Karyn Young '91

Karyn Young. *Spring.* Silkscreen print, with chine collé, stencil-dyed, and handcoloring. Ed. 48. 1991.

I represented Joshua Rome for several years before actually meeting him face to face. I had just finished hanging the prints and paintings in my exhibition space for the Works on Paper show at the Armory in New York. A man in his early forties approached me and asked why I had a Brian Williams snow scene on display rather than one of Joshua Rome's snow scenes. Initially, I thought the man was a little crazy. "Why do you care?" I asked. "I am Joshua Rome," he replied, and we both had a good laugh.

To create his beautiful woodblock prints, Joshua does all the carving and printing himself, producing about six prints per year. My favorites tend to be his winter scenes. They have the peacefulness of the old ukiyo-e, but the imagery is often brought to the foreground, giving the viewer a close-up look at rural Japan.

Since moving to Japan twenty-one years ago, Joshua has been looking for the old Japan, which he finds is vanishing all too quickly. Appropriately, his home is an "up-in-the-mountains-peasant-type-house," with a detached outhouse and bath. He describes it as "rustic and a bit Spartan." In fact, the man who owned the house before him stopped plowing with cows in 1981. The most remote structure in a village of twelve houses, Joshua's farmhouse sits on an acre of land.

In the fall of 1995, I was Joshua's guest for a night. He picked me up in his van and proceeded to take me on a wild ride into the hills of Kyoto, cursing anyone who got in his way. It felt like I was taking a New York taxi ride in rural Japan. Upon our arrival, we were greeted by Joshua's two young daughters, Leah and Shoshonna, and his wife Michiko, who is a kimono dyer. Several dogs emerged from a rickety doghouse, and three roosters strutted by. That night, after Joshua had played with his children and tucked

JOSHUA ROME

them in, he and I stayed up until one in the morning talking and playing poker. (I beat him.) At 6:00 A.M., his roosters crowed and I awoke in the mountains of Kyoto, amidst the scenery in Joshua's prints.

Joshua said that his interest in what is left of traditional Japan was sparked the first time he visited the Orient as a teenager. "When I came to Japan, I came to Tokyo first, and Tokyo was just New York in Chinese characters—a big international city. I wanted to know Who is Japan? What is Japan? When I went to Kyoto on New Years, that's when I got thrown into the fourteenth century. It was dark. Everyone was running around in kimonos, ringing big temple bells. You could really ignore the twentieth century. If you didn't look at the telephone poles, you could be somewhere else."

After moving to Japan later the same year, he continued to seek the connection between the twentieth century and the pre-Meiji period of the shoguns and the samurai. When he moved out to the country, he "found people who were living basically how they were before." The changes Joshua has witnessed since then have inspired his art.

"You saw this gross acceleration of the destruction of the countryside in favor of prefabrications," he said. "My outrage prompted me to make more of my prints."

His print "Enryo no Katamari (The Last One)" is a good example. The title is a play

on words: "There's one persimmon hanging on the tree in the middle of winter," he said. "It was probably too high to pull off. It's also the last print I made. And this is the last time I'll make this kind of print [snow scene]." The Japanese title has a similar but idiosyncratic meaning. "If there's a whole bunch of food on a plate and everyone keeps eating until there's one piece of food left, everybody's too polite to take the last piece. That's *enryo no katamari*," Joshua explained.

"Seijaku," or "Quietness," a long, narrow print, is another snow scene. It was done in the northern Alps of Japan in February. Joshua can still remember how bitterly cold it was at the time. The print "Tsukiakari (Moonlight)" was completed on the same trip, but in the southern Alps. "My wife and I had driven with our children from Kyoto," Joshua said. "My brother-in-law had a summer house in the southern Alps—not something you want to use in the wintertime—but it beats a tent. We used it as a base camp while I went painting in the Alps. We'd try to find all the little hamlets off in the middle of nowhere.

"Before I'd go on these trips," he continued, "I'd try to read up on the history of the place, so I'd have something to inspire me. That whole area up there during the Tokugawa period was pretty oppressed. Their taxes were high, and rice production was low. To try to conceptualize that, I made the snow deeper and the eaves sag a little more."

Joshua has had plenty of time to find the out-of-the-way places he depicts. "I've been in Japan twenty-one years. I'm forty-two. That's half my life," he said. "I've spent my entire adult life in Japan, which is why I'm so weird. It's time for a change."

In reviewing his recent decision to return to the United States, Joshua explained that he worries about his children's education and their future in the homogeneous Japanese society. "They'll have more opportunity to spread their wings, get shot at, and take drugs in the United States," he said.

While I was staying at Joshua's home in Kyoto, before he moved back to the states, he told me about how he became a woodblock printer so many years ago. He was born in New York City in 1953. His father, Harold Rome, was a famous composer and lyricist of Broadway plays. When Joshua was fifteen, his parents went to Japan to do a musical production of *Gone with the Wind*. His mother ended up writing a book about the Japanese underworld, and his parents were in and out of Japan from that time on. In 1973, the Tōhō Theater Company offered to pay for the whole family, including Joshua and his sister, to come to Japan.

While in Japan, Joshua and his family were introduced to Clifton Karhu, an important American artist who has been in Japan for more than thirty years. "We went over to Karhu's house," Joshua said. "He said that if I ever came back to Japan, I should look him up and he would show me how to make woodblocks. I don't think he offered that to anyone else. He probably said it offhandedly, but he did give me his phone number."

The following spring, in 1974, Joshua decided to move to Japan, mainly because he "didn't have anything better to do with his life." Since dropping out of medical school, he had worked in fruit orchards in Oregon and had returned to New York, where he was doing carpentry for a graphic design company while living with his parents. This was an opportunity "to lose myself in a culture I knew nothing about." He had plans "to go back to the land of reality [United States]" after two or three months.

"I washed boats on Lake Biwa for a living," Joshua said. "Everybody else taught English; I washed boats. It paid better than teaching English, and I was outside all day, which made me happier all the way around. I also washed dishes in a restaurant in Kyoto. I lived with the guys who were the cooks and they spoke no English. I picked up a lot of my

Japanese from them—eventually, when you get hungry, you gotta learn. My language was rude before it was polite, while everyone else was polite before being rude. I still find it hard to be polite."

After some time, Joshua had a fight with his sponsor in Japan and found himself without a sponsor, a place to live, or a job. After straightening out two of the three problems, he called Clifton Karhu, who took him out to lunch. Karhu said he couldn't pay Joshua but he would be happy to teach him woodblock printing.

At that point, Joshua's main interest was cabinetry. As a result, the woodblock-printing tools and the relief carving were the intriguing part of the craft for him. He ended up working for Karhu for three years, and in fact, he was paid a small per diem. Joshua is surprised he wasn't fired the first day.

"Karhu would mark out the blocks. The first day he showed me how to carve them. He had scored them with a knife first—I would just carve out all the garbage. But I carved where I was supposed to leave it, and I left what I was supposed to carve. I did the exact opposite. He came back and took me out for a sushi dinner, but he probably wanted to strangle me."

Joshua thoroughly enjoyed his apprenticeship to Karhu, whom he describes as a "lighthearted, nice person" to work for. From Karhu, Joshua learned about the Japanese culture—"all the offbeat things that friends have to teach you." Karhu's wife fed Joshua lunch, and his teacher occasionally took him to dinner at "outrageously expensive sushi places." Joshua also remembers with fondness Karhu's habit of watching sumo tournaments on television while working on his woodblock prints.

At the end of each day, when Joshua would get his 1,000 yen, he would go straight to the pachinko parlors. If he doubled his earnings, he could go out on a movie date with a girl. "Decadence. I loved it," Joshua said of those times. In the summer, Karhu would throw Joshua "a hunk of money" and go fishing, while Joshua hitchhiked around Japan.

During the years they worked together, Karhu's valuable knowledge started trickling through, although Joshua's style and palette are very different from his teacher's. "At Karhu's house, there were two tables facing each other," Joshua said. "I'd be sitting at one carving, and he would be standing there printing, looking at me carving. He would be trying to teach me color theory. I wasn't interested in color theory, but you hear it all day long, you absorb it.

"I started making postcard-size prints at home just for fun to see if I could do it. All these things he'd been telling me would start making sense. But I was much more interested in learning the skill of fine carving, as opposed to looking at the whole concept of what a print is. The technical aspect was more interesting than the artistic aspect. I started selling these prints to buy tools, paper, beer."

In accordance with an old Japanese proverb—If you don't know it in three years, you're not going to learn it in ten—Karhu kept Joshua as an apprentice for three years.

For the following three years, Joshua concentrated on studying Japanese cabinetry with Kenkichi Kuroda, the son of a National Treasure in lacquerware. "He had real *deshis* in his house—two Japanese who were ten-year indentured servants. Having a white boy move in wasn't the greatest," Joshua explained. "I had been in Japan three and a half years. I knew the basic ropes, but you don't wash out your cultural heritage that easily. I started breaking the ice, and we did end up getting along, They started to understand that I wasn't all that crazy."

But the training was grueling and meticulous. For eight hours a day, Joshua would

sharpen chisels until his fingers bled. After "umpteen months" of that, he made plane bodies (carpenter's planes), and then graduated to trays. Fortunately, another American joined the group in year two. He was so amusing and flamboyant that the Japanese started to realize that all foreigners are crazy. "They started to lighten up, and there was more cross-cultural understanding," Joshua said.

Joshua enjoyed the warm family atmosphere at his teacher's home—eating lunches and occasional dinners, and even sleeping overnight. Kuroda also took his apprentices to the studios of many great potters and woodworkers, an experience that Joshua feels was more enriching than any college education.

In his seventh year in Japan, Joshua met Michiko and decided he would settle down. "I went with my wife-to-be to Tokyo to meet her parents. Her father gave me a lecture about life and duty," Joshua said. "He looked straight at me and said, 'I'm not saying no, I'm saying yes.' He [suggested] I either take woodblock printing and do it, or take cabinetry and do it."

As if to help Joshua choose a path, the Fran-Nell Gallery in Tokyo had taken two large, half-sheet prints of Joshua's a few months earlier. The gallery also introduced Joshua to CWAJ, and he ended up showing two prints in their twenty-fifth anniversary show.

"At that time, I was about the only new artist in that show. They said, 'You're our new face.' There were maybe eighty to one hundred artists. I was so uptight to be in that show, I was quaking in my boots—I hate rejection. I sold out, which gave me the biggest ego on the face of the earth. I've been with them ever since."

Coincidentally, Tetsuko Kuroyanagi, a friend whom Joshua had known as a teenager, had a television show that was the Japanese equivalent of Oprah Winfrey or Johnny Carson. Tetsuko said Joshua could be on her show as soon as he had a one-man show. Not long after, Joshua appeared on television on the opening day of his first show at a Tokyo department store. As a result, the opening was "like Grand Central Station at 5:00 P.M." The success of that show enabled Joshua and Michiko to buy their house tucked away in the mountains.

Before they had children, Joshua and his wife grew all their own food on the land around the house. Now they grow a half year's supply of rice, fifty to sixty tomato plants, five hundred stalks of corn, and almost anything else you can name. Joshua says he is adamant about not using chemicals and "makes a nuisance of himself" yelling at people who insist on them. In the same way, he's a purist about his woodblock printing.

"From start to finish, I don't use printers. I don't use carvers. I don't use anybody, because you can play with it more if you do it yourself," Joshua said. "After I print the block one hundred times, I can recut that block and use it again as a different color. If you have a carver, you can't change the shapes of the colors. If you do your own work, it can be much more spontaneous. It's a lot more fun to play with it and not know where you'll end up."

Joshua admits he hates analyzing his finished work, "The print should be enough, shouldn't it? There it is. Look at it. If you get a feeling from it, I've done my job. I understand what I do, and that's all that matters.

"There are individual prints that are very emotional for me," he added. "They show the sadness or the anger of when I was doing them. A lot of them express a way of life I am seeing the end of—the end of the Japan I moved to the country to find. All of my prints are rural farming scenes of things that are no longer or will soon no longer be. My prints preserve a memory of that heritage."

ジョシュア・ロームはマンハッタンの5番街に生まれた．現在は京都の丘陵地帯の農家風の家に妻の美智子と2人の娘といっしょに住んでいる．1974年に初めて日本に来た彼は，琵琶湖で船を洗うことと京都のレストランでの皿洗いによって自活した．やがて，すでに30年以上も日本で生活しているアメリカ人の有名な版画家クリフトン・カーフの弟子となり，3年間修行した．ジョシュアの手になる木版画は常に情感に満ち満ちていて，彼自身は言うに及ばず，見る人の心を動かすものがある．「田園破壊の加速」に対する怒りが彼の版画製作の動機だと彼自身語っている．そのことを彼は「日本に来て最後の日本を見つつあるのです．私の版画はどれも農村の伝統的な光景ばかりですが，そういう光景はもはやなくなってしまったか，間もなくなくなろうとしています．私の版画はそうした光景を保存するためにあるのです」と表現している．

ジョシュア・ローム「樵」（木版，Ed.100，1984年）
ジョシュア・ローム「稲木」（木版，Ed.90，1990年）
ジョシュア・ローム「冬の日」（木版，Ed.100，1981年）
ジョシュア・ローム「静寂」（木版，Ed.95，1991年）
ジョシュア・ローム「田植え」（木版，1981年）
ジョシュア・ローム「春雨」（木版，Ed.100，1986年）
ジョシュア・ローム「最後」（木版，Ed.95，1994年）

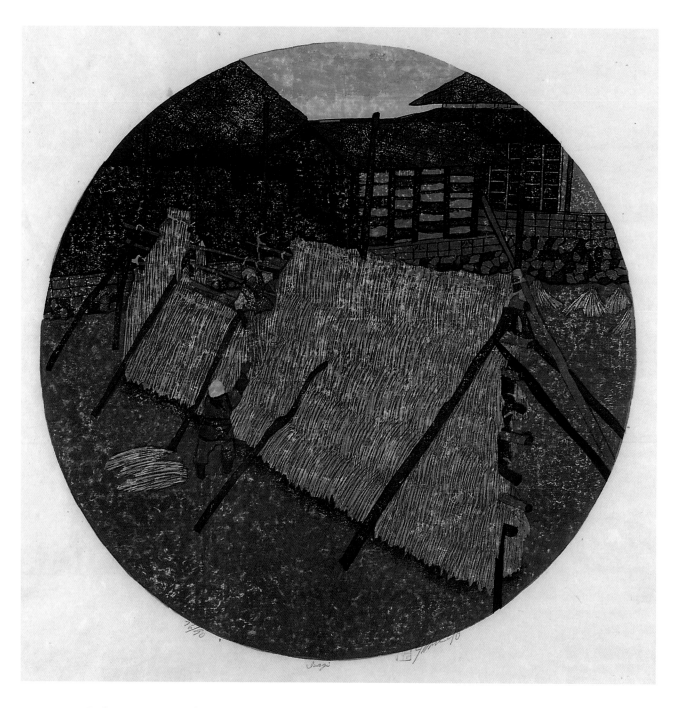

Joshua Rome. *Inagi* (Rice Drying). Woodblock print. Ed. 90. 1990

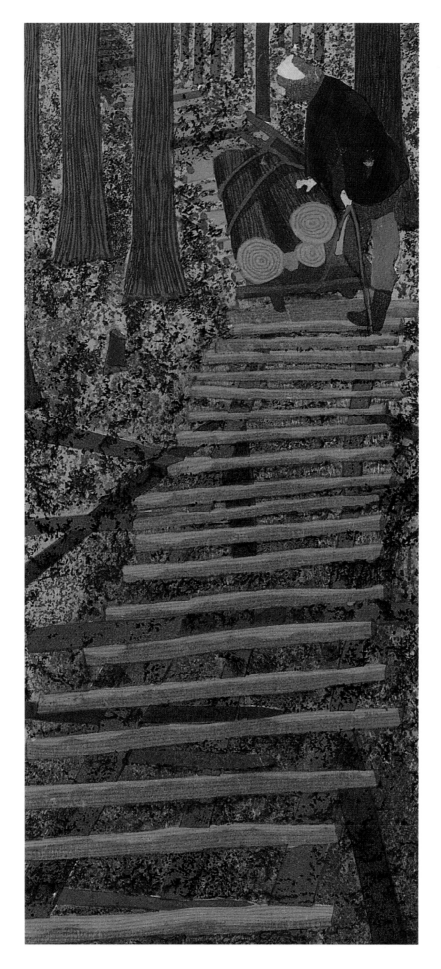

Joshua Rome. *Kikori* (Logging). Woodblock print. Ed. 100. 1984

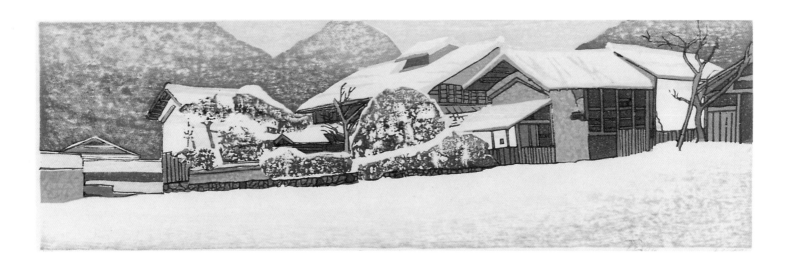

Joshua Rome. *Fuyu No Hi* (Winter Day). Woodblock Print. Ed. 100. 1981

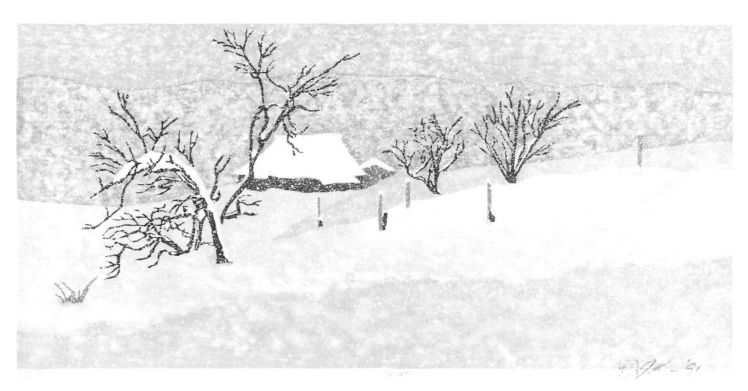

Joshua Rome. *Seijaku* (Quietness). Woodblock print. Ed. 95. 1991

Joshua Rome. *Enryo no Katamari* (The Last One). Woodblock print. Ed. 95. 1986

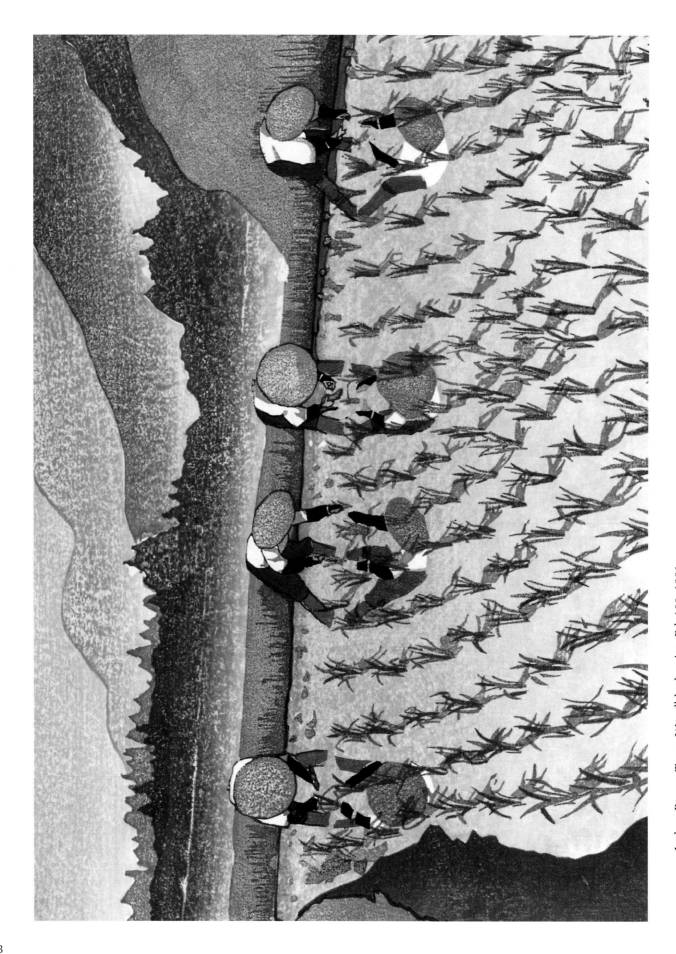

Joshua Rome. *Tau-e*. Woodblock print. Ed. 100. 1981

Joshua Rome. *Amawaka No Harusame* (Spring Rain in Amawaka). Woodblock print. Ed. 100. 1986

39

Margaret Kennard Johnson is the most modern and, at the same time, the most traditionally Japanese of all the printmakers I represent. She and her husband Ed, who was an executive with RCA, moved to Tokyo in 1975, where they lived for eight and a half years. Margaret was fifty-seven years old when they first arrived. She was a successful printmaker who had taught for over twenty years at the Museum of Modern Art in New York. Yet her work went through a profound change as a result of living in Japan.

"I felt as though my husband and I were children again when we went over there," Margaret told me. "We were noticing everything. It was as though we had awakened with the curiosity of a little child.

"I was ripe to find what I did," she continued. "I was drawn to the simplicities. The elegant simplicity and the reserve were pervasive, not just in a visual sense, but in life in general."

When Margaret first arrived in Japan, she immediately started looking for a place with an etching press where she could complete a commissioned work. She ended up at a workshop with almost exclusively young, male, Japanese printmakers. They didn't speak each other's language, but the working space was so cramped that they quickly became acquainted. (Once she looked down to find a Japanese woman drying a print underneath her press!) The other printmakers were very kind to her and informed her of exhibitions in town.

"I was less influenced by the art of the contemporary artists than I was by the traditional culture," Margaret said. "I loved to go to calligraphy exhibitions where the white spaces were so beautiful between the brush strokes. I loved seeing the Japanese tea ceremony room and the traditional Japanese houses with their sparseness."

From the Japanese, she learned that she didn't have to do a lot of shouting to create excitement. "We went to a Noh play," she explained. "This character, although in an elaborate costume, came out on the stage and just stood there for I don't know how long. And then he wiggled his toe, and that was a big event!"

In the same vein, Margaret found she could use space in such a way that very little is depicted and most of the image is suggested. These discoveries lent a peaceful, serene feeling to her work.

Margaret's background prepared her to appreciate the restraint she found in the Japanese culture. Her education had included working with Josef Albers at Black Mountain College one summer. Albers, who had taught at the Bauhaus in Germany, is famous for his homages to the square and for his teaching. Margaret learned about the concept of less is more, about how color changes in relationship to other colors, and about giving a three-dimensional quality to a two-dimensional object. These lessons were reawakened in Japan.

A number of pivotal events in her Japanese experience stand out for Margaret. The first is related to the ancient bronzes she saw—three-thousand-year-old Chinese and Japanese food vessels with rich patinas from having spent time in the earth. "I was doing

a medieval image, which had been inspired by living in Zurich for a year. I was close to getting this print finished. I walked away and came back and saw it upside-down."

Margaret thought the image looked like one of the Chinese food vessels from that vantage point, and that's how she completed the piece. For several years after that she did takeoffs on the ancient artifacts she saw in Japan.

This led to an intriguing print entitled "Homage to Future Relics." When I tell visitors in the gallery about this print, I have them imagine they are archaeologists from the year 3000, and they've just made a great discovery from the 1960s. Many people think the image looks like an ancient head from the Aztecs or the Maya. But in actuality, it's a manual typewriter that Margaret's mother gave her when she graduated from high school!

A dormant period in the middle of Margaret's Japanese stay was also of great significance for her. For about a year, starting in 1979, she barely touched a printing press. Her time was taken up writing a book with Dale Hilton, *Japanese Prints Today: Tradition with Innovation,* in which she interviewed contemporary printmakers.

"When I got back to my own work," Margaret said, "everything looked contrived and complicated. I kept removing shapes until my compositions were getting very bare. I began to do some very simple work."

Margaret was deeply affected not only by the artists she interviewed, but also by the subtleties in every phase of Japanese life—from the varying tastes of green teas to the colors she saw on the streets. Although there were many instances of bright color, she was drawn to the subtle hues. She was also attracted to the combinations of colors and patterns so tastefully put together, such as those on a kimono and the obi, or sash, that is wrapped around it.

At that same time, a young papermaker precipitated a turning point in Margaret's development. He presented her with a piece of handmade paper and told her that if she made a print on it, he would include it in a show in Kyoto. At first, Margaret wondered how she could possibly improve on this beautiful paper without ruining it. But through this experience, a whole new approach was opened up to her.

"I began to think, How can I make the paper I print on an active participant and not just an inert bed on which to print? That's when I started working with embossments and folding it [the paper], and that's what got me going with mesh."

The predominant themes in Margaret's work are time and space—the infinite. The meshes she began working with—mushroom bags, wedding veils, orange bags, black mourning veils—were to be important in expressing those themes.

"When I first began working with mesh, I let the mesh tell me what to do. But when Ed first discovered that he had cancer, from that point on, we didn't take for granted the future. I began using the mesh philosophically. I found it was able to serve me for some deeper things I wanted to express. I began to do a series that had to do with the pages of a book, or a schedule actually. I often thought, What am I going to be writing in the future?" Margaret said.

In "Silent Comment," which shows two pages and the spine of a diarylike book, the pages are empty because they represent the unknown future. Margaret didn't think of the future in a "depressed way" however, but rather "the mystery of it, the fascination of it." To add "quiet, whispery shapes" to the mesh effect she would sometimes put cardboard under the mesh, leaving a very subtle edge where the press traveled over the cardboard.

Not surprisingly, Margaret has always been interested in the past as well as the future. "I've been obsessed with the old walls on the temple grounds and the mysteries of

old temple doors where the hinges have been replaced and you see where they had been." She was doing a whole series of prints that looked like writing from the past, that had the feeling of old manuscripts, with their burnt edges and brown-colored paper. For these pieces, intaglio worked best because she could make the surface look archaeological. Margaret uses cardboard plates and modeling paste for the intaglio. She digs into the modeling paste to get texture. Then the ink is rubbed into the lower levels of the design, the top surface is flatly wiped, and the image is printed onto dampened paper.

But the past and future were not the whole picture. When Margaret and Ed traveled to Antarctica, Margaret found that it was the space that was infinite. "I'd been working with time being an unknown. In Antarctica, you'd see this vast space where the horizon would disappear. It was so sparse and spacious and remote. I couldn't think of any other way to express it except the meshes. The unknowns, the mystery of what's ahead in time and space, has intrigued me a lot ever since."

I met Margaret around 1991. Her coauthor, Dale Hilton, had moved to Cleveland a few years earlier. With Dale's interest in contemporary prints, she soon found our gallery and asked if we would like to meet Margaret.

Margaret came to the gallery on the way to a reunion at the College of Wooster. I was fascinated by her abstractions, which are deceptively simple but hold a deeper meaning. It was the first time I could remember totally understanding a piece of modern art. I also liked the fact that her work, such as the book pages, with their unwritten text and their hieroglyphic symbols, left a lot for the viewer to fill in from his or her own experience of life.

When I asked Margaret to explain the images in "Beyond the Window," she could only tell me that the small square at the top of the print represented the rearview mirror of a vehicle, which symbolized looking back. After taking a bus ride to the reunion and seeing the scenery of her childhood and college years out the bus windows, Margaret realized that, in her print, she had depicted the red farmhouses that dot the countryside in Ohio.

Another of her pieces, "Harvest," done in 1976, is a print representing sheaves of rice being harvested in Japan. It was created by pleating aluminum foil and inking the foil. Here is a case where the technique and the imagery may be simple—the print may have taken about a week to complete—but the idea took a lifetime to develop.

Some of my favorites among Margaret's work are the cut-paper images. For instance, "Unfolding Thought" shows how a thought or idea evolves. It consists of a sequence of three prints in which the flaps of an *X* cut in the paper are shown unfolding in consecutive order. "I used to work in sculpture," Margaret told me as we looked through the cut-paper images. "It looks like some of that wants to come out."

Margaret explained her sculptured-paper technique further: "I can scratch it and cut it and fold it and bend it. I've wet Japanese paper and taken an etching needle and pulled up the threads. Where it fits in as a means of expressing something, I do it."

For example, in "What of Tomorrow?" she cut a flap and lifted it up "like an awning" so that you can't quite see the imagery underneath. It makes you think that you can guess what's there, but you can't—again a powerful yet subtle way of depicting the unknown future.

Looking back, Margaret said that art has been a part of her life since she was a child. Her mother taught at the College of Wooster and was her first teacher. Following her mother's path, Margaret has also taught extensively—at the Museum of Modern Art, Drake University, Texas State College for Women, and currently at Artworks: The Visual

Arts School of Princeton and Trenton. She relishes the balance between teaching and doing her own work. Although she knows of no one else who is working with mesh the way she does, she imagines some of her students might do so in the future.

In 1992 Margaret had a one-woman show at my gallery. Her work has also been collected by the Cleveland Museum of Art, the Minneapolis Art Museum, and the British Museum. Every year I invite her to be our guest at the Works on Paper show in New York. No matter the weather conditions, Margaret arrives at the show to explain her new imagery. The prints over the years have depicted her travels to Antarctica, Egypt, Iceland, the Grand Canyon, and of course, Japan.

At this stage, Margaret would like to do more three-dimensional pieces but she has so many ideas she wants to pursue. "I just keep going because I hope the next print will be better. I love experimenting. Even when I get the image the way I want it to be, I'll explore color possibilities."

The last time we talked, we discussed how the era an artist is trained in can affect his or her work. For context, Margaret said she was born in 1918. "I was trained during the era that stressed the integrity of the materials, the aesthetic value, the composition," she said. "It was important to have an integrated whole."

Margaret went on, "I love the idea of trying to do something or say something that contributes to a balance or serenity in this world that's so chaotic. I hope there's room for things that seem to have some order and some meditative quality. It helps me have my own serenity to do the work I'm doing. I hope it has some use for other people."

マーガレット・ケナード・ジョンソンは最も現代的でありながら，最も日本的な版画家である．オハイオ州ウースターで生まれた彼女は，ブラック・マウンテン学院でジョセフ・アルバースの教えを受けた．1975年，夫のエドと共に東京へ行き，8年半を過ごしたのであるが，2人が初めて日本へ行ったとき，マーガレットは57歳であった．それまでにすでに版画家として成功しており，ニューヨークの現代美術館で20年以上も教えてきたのであった．だが，彼女の作風は日本生活の「優雅な簡素と慎み」の中で過ごした結果として深みのある変化を示すようになった．マーガレットの作品の主要なテーマは「無限の時空」ということである．彼女は次のように語る．「私は非常に混沌としたこの世界に平衡と落ち着きをもたらすための何らかのアイデアを試みたり語ったりすることが好きなんです．何らかの秩序と瞑想のようなものを許容すべき空間があることを望んでいます．仕事を進めるための私自身の落ち着きをもたらしてくれるからです．それがまた他の人々にとっても何らか寄与することがあれば幸いです」．

マーガレット・ジョンソン「収穫」（インタグリオ・レリーフ，Ed.20，1976年）
マーガレット・ジョンソン「窓の向こう」（レリーフ，Ed.10，1994年）
マーガレット・ジョンソン「沈黙の注釈」（レリーフ，紙版，Ed.10）
マーガレット・ジョンソン「未来の面影への讃歌」（インタグリオ・レリーフ，Ed.20，1977年）
マーガレット・ジョンソン「どこ」（インタグリオ・レリーフ，Ed.30，1982年）
マーガレット・ジョンソン「過去の存在」（インタグリオ・レリーフ，Ed.15，1990年）
マーガレット・ジョンソン「思考を開く」（レリーフ，紙版，Ed.10）

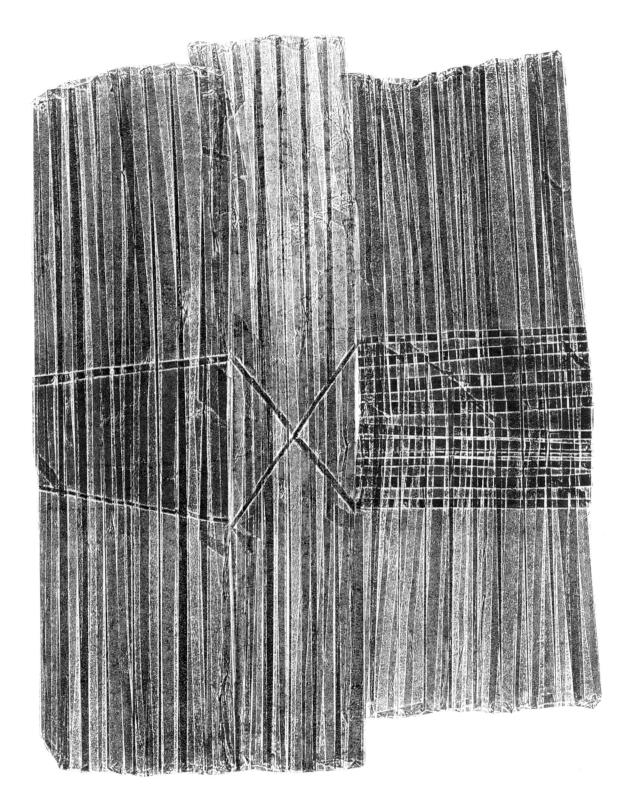

Margaret Kennard Johnson. *Harvest.* Intaglio relief. Ed. 20. 1976

Margaret Kennard Johnson. *Silent Comment.* Relief, sculptured paper. Ed. 10. 1989

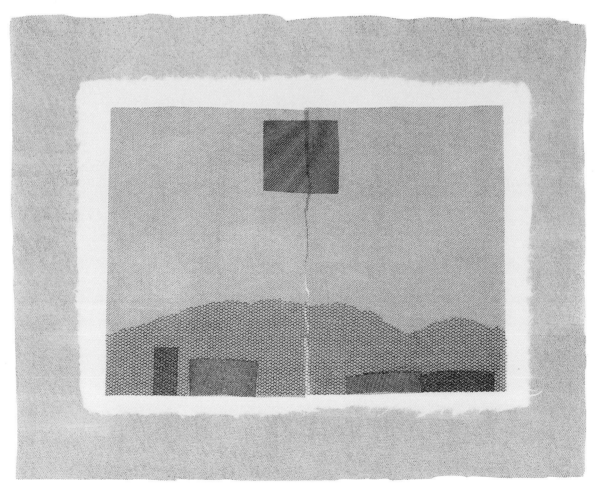

Margaret Kennard Johnson. *Beyond the Window.* Relief. Ed. 10. 1994

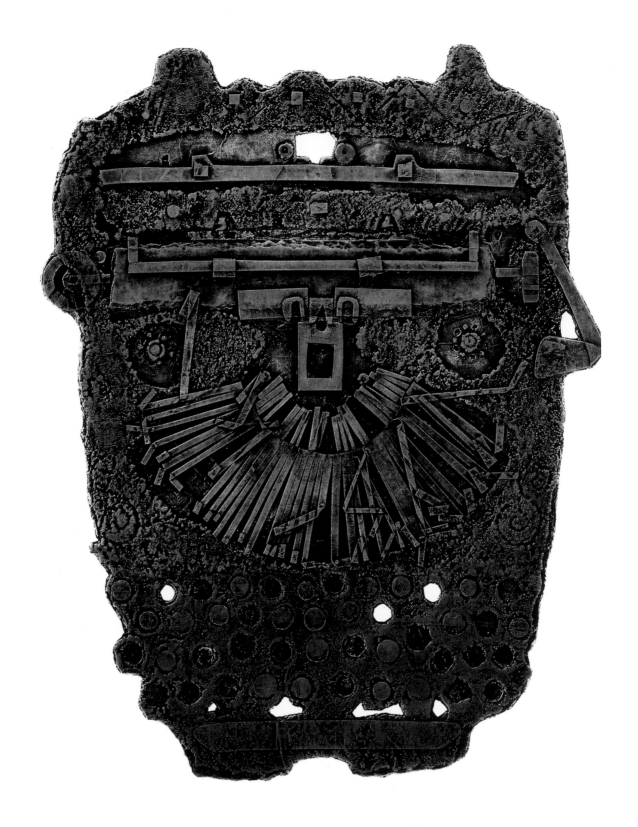

Margaret Kennard Johnson. *Homage to Future Relics.* Intaglio relief. Ed. 20. 1977

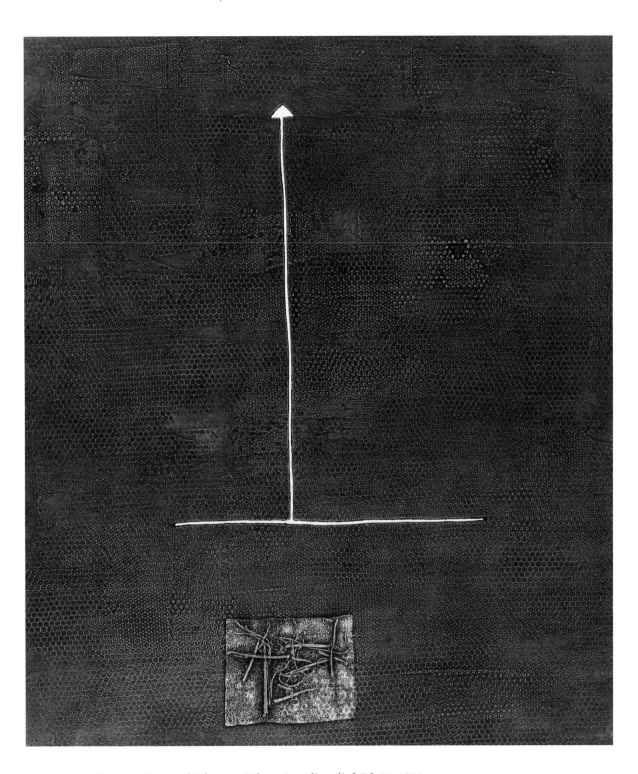

Margaret Kennard Johnson. *Where.* Intaglio relief. Ed. 30. 1982

Margaret Kennard Johnson. *Past Presence.* Intaglio relief. Ed. 15. 1990

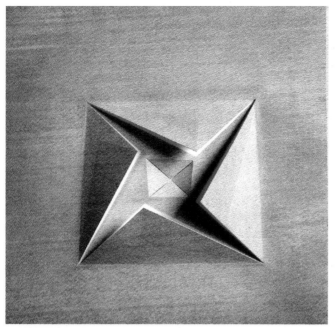

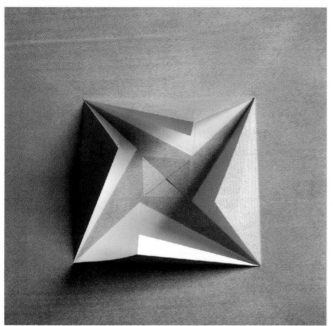

Margaret Kennard Johnson. *Unfolding Thought.*
Relief, sculptured paper. Ed. 10. 1989

During one of Daniel Kelly's many visits to our gallery, he unveiled a group of prints by Joel Stewart, an American artist living in Kyoto. Although I didn't select any pieces from the original group, I felt Joel had great potential. Approximately six months later, Joel sent a magnificent handcolored etching called "Floating World." After a rain, the Japanese all over Kyoto lay out their umbrellas to dry. Joel's print depicts two rows of bluish-white umbrellas drying in the courtyard of a teahouse. They form an intriguing pattern, their angles creating an interesting visual effect.

Although the printing stage of this etching took Joel as much as one or two hours per print, he felt it was worth the effort. "The reason I do etching, although it is a lot more painstaking than painting, is because I think the etching format, with its textures and its high pressure and oil-based inks, really produces a rich print," Joel says.

"I'm in a good mood when I'm in the proofing stage," he continues. "Proofing, testing, seeking that satisfactory image—that's all exciting. After I've done the first run, I'm spent. I have to get psyched up to do the rest."

Joel created his next great print, "Looking Back," in 1994. This etching is also representative of the calm side of Joel's work, which makes it well-suited to my gallery. It is a snow scene of a 150-year-old house not far from Joel's studio. The building is one of the last remaining *minka,* or traditional homes, in Kyoto. Joel has done a rendering of the steps leading to the back entrance of the house, which is used most frequently, as opposed to the grand front entrance, which is generally reserved for auspicious occasions. The title refers not only to the back of the house, but also to the idea of looking back in time. Half of the snow that appears in the print is on the plates, and half is handcolored.

JOEL
STEWART

Joel's semi-still lifes, like his other work, are a direct result of living in Kyoto. He describes the nature of the city in this way, "Kyoto is mostly a 'close-up' place. It has narrow streets. It's personality is narrow. It's the Boston of the East—very proud and conservative."

Over his ten years in Kyoto, Joel has painted semi-still lifes of seemingly ordinary objects in his neighborhood—a grouping of pickle barrels lined up and stacked in a haphazard fashion, a brass lantern hanging in a shrine, racks of daikon set out to dry by a farmer who lives nearby.

Of his subject matter, Joel says: "To recreate an image is in some way to own it. I feel like I want that object in my life. If I can capture it visually, I've achieved that.

"Years before I went to Japan, I did a very large painting that included an old Gothic church," he adds. "I found that as I was drawing it, I felt like I had to rebuild the church by myself. Art for me is, in a way, a process of rebuilding/remaking."

Joel uses watercolor when he ventures outside to recreate the countryside within an hour's distance of his house. While out in nature, he says, it's important for him to be in tune with his surroundings. For Joel, this means "emptying himself," soaking up the sensory images, and then acting on what he has seen by creating a painting.

"You lose yourself and then you get yourself back," he says.

Joel can walk outside his door and paint Mount Hiei and the rolling foothills around it. Only five minutes away is the Kamo River, which is like Kyoto's Central Park. Lake Biwa is also a favorite spot for his panoramic watercolors and oils.

"The great thing about Japan is the range of light throughout the year," he says. "Basically, winter is monochromatic and summer is tropical. And in between those two extremes is an incredible array of color and texture and qualities of light. By tropical, I mean skies that have fantastic blazing pink hues, green, even dark purple, slates—just a candy store of colors. Winter is the grays and monochromes. It's much more like an ink painting, more graphic. Snow brings out the abstract in nature and the lovely abstract qualities of the buildings."

"What I've learned from doing watercolor painting," Joel continues, "is that the traditional woodblock artists didn't invent the landscapes. The landscapes still look like that. The Eastern haze provides an incredible array of color."

Joel has been living in the midst of these landscapes since 1986. Several years after graduating from Pitzer College in California with a double major in art and anthropology, he felt like he wanted to see "what else was out there."

"At the wise, old age of twenty-six, it was a time of my life that I could pick up and go," Joel says. "I had been pursuing art, and I wasn't tied to any other type of work."

Joel had grown up on *National Geographic* and had spent many hours staring at the women in the Japanese woodblock prints his father had brought home from a business trip. "Those woodblock prints were mysterious because they were *bijin-ga*, portraits of beauties," Joel says. "The ones in our house had two beauties with black teeth. I could not for the life of me figure that out. That was my first contact with Japan."

After college, it came down to a choice between Africa and Japan. Deciding he had more contacts in Japan, Joel ended up getting a visa to teach there.

His first day in the Orient, Joel stayed in Kobe. The trees and the traditional Japanese-style homes around him fit his image of Japan, even though "it wasn't quite *National Geographic* temples in the snow." It was the drive to the school where he was to work that proved shocking. The scenery all along the two-hour drive consisted of "concrete jungle and urban sprawl." "I had grown up in the northwest," Joel explains. "Here I was in a strange country, with different customs, and no nature to be seen."

Joel lived in an apartment complex, in living quarters he describes as a "rabbit hutch." Eventually he negotiated a part-time teaching schedule in order to devote more time to painting. One saving feature of the area where he lived, which was between Kyoto and Osaka, was a historic shrine perched on a hill, flanked by a large bamboo forest.

"That was my little pocket of nature," Joel says. "Bamboo forests are really magical for me. I remember walking up to the shrine—it was spring, which is when the bamboo shoots are coming out. I was able to watch this farmer—he was a sixty- or seventy-year-old man—harvest the bamboo shoots. It was so great just to watch him. He was very graceful. The sounds in a bamboo forest are so different. They clack together in the wind. They make pops and cracks. This was something I could appreciate at the time."

Joel also looked forward to going to Kyoto on weekends, where he met Brian Williams, Daniel Kelly, Sarah Brayer, and many other artists. "The trouble was being so isolated. I'd come into Kyoto, and at eleven o'clock at night, I'd have to catch the train back to my cubbyhole. It was lonely—being so charged up and having to go back."

On the bright side, Joel enjoyed his weekends, and he met several Japanese artists through a number of art shows and competitions in which he exhibited his work. But by

the end of the year he wasn't sure he wanted to stay in Japan. His wife Becky was instrumental in that decision. She had visited Joel before they were married, and they had had a wonderful time traveling around Japan. Shortly after the trip, Joel telephoned Becky from Japan and asked her to marry him.

"Becky wanted to explore the world, and at the last minute we decided to live in Japan," Joel says. "But I didn't want her to experience the same sense of isolation I had, so we chose Kyoto to live. That made all the difference. We had contact with other foreigners, and the historical, decorative aspects of Japan were right at our fingertips."

In his early years in Japan, Joel continued working in the style he had been pursuing in the United States—a combination of realism and abstraction. After the abstraction ran its course, Joel's work became more representational. He remembers with fondness the first time he went out painting on location with Daniel Kelly.

"Daniel and I had been friends for four or five years," Joel says. "Daniel was in his landscape painting phase. He said, 'I'm going painting. Why don't you come along?' and I said okay. It was fall. We set up our easels in front of a rice paddy that had been freshly harvested. We also had a great view of Mount Hiei. We did three or four paintings in the course of the sitting. It kept getting darker. We had a nice sunset. Then the moon came up behind Hiei-san [the mountain]. It seemed so special—we were painting on location and having fun—and the icing on the cake was the moon. We were frantically painting the moon, trying to capture the moment. To have that experience the first time out, I was hooked. I started painting outside from that point on. It was a whole new subject matter, a whole new set of rules, a whole Zenlike thing of capturing the moment."

Joel is the youngest of all the artists I represent, and I have watched him mature as an artist over the years. We had our first success with the etching "Floating World." Then in 1994, the response to "Looking Back" was immediately positive. I thought that Joel had finally arrived and was ready to take off. Little did I know that his studio would burn down one week later. One of the artists I represent called to tell me of the tragedy.

Daniel Kelly and Joel both smoke cigarettes and they light them with either a blowtorch or a candle. When Joel took Daniel to the train station, he forgot he had left the candle in the sink on top of a piece of cardboard. The candle burned the cardboard, which fell into the plastic disposal, and the studio went up in a ball of flame.

Ten months later, I visited Joel in Kyoto. As he treated me to a delicious meal he had prepared himself, he spoke of his struggles to recover after the fire. In this transition period, he said he was spending a great deal of time painting watercolor landscapes with Brian Williams. In contrast to these outdoor scenes, he showed me his latest work, a lovely still life entitled "Floating Vase."

As to the future, Joel has proven that he can produce works that are of a high quality and that are appealing to print collectors throughout the world. As a preview of prints to come, Joel took me to the Shoden-ji, a Buddhist temple built in the thirteenth century. Surrounding the temple is a Zen garden that Joel has chosen as the subject of his next print. While viewing the garden, Joel reflected again on the fire.

"It was kind of cleansing in a way," he said. "I lost some originals, some prints, and some materials. Had I lost more prints, it would take more energy to bounce back. With the time they took, I wouldn't go back and do those again. Losing some of the originals—like my first oil painting—that was hard. But if any original is a strong enough image and is important enough to me, if a subject isn't a closed chapter, I feel it will resurface in my life."

ジョエル・ステュワートはカリフォルニア州ダンヴィルで生まれた．26歳の時，神戸に行き，やがて友人で美術家でもあるダニエル・ケリーとブライアン・ウィリアムズが住む京都に移った．若手画家である彼の関心は，京都の風景と静かな生活に焦点を結んでいき，その地で10年を過ごすことになり，「日本の歴史的かつ装飾的な姿はまさに私の手の内にある」と語ったものだ．1995年，一人立ちできるだけの腕がついてきたとき，蝋燭をつけ忘れたために，スタジオが焼け落ちてしまった．彼は「それはある種の浄化であった．原画，版画，材料などのいくつかを失ってしまった．もっと作品を失っていたら，もとに戻すためのエネルギーがもっと涌いたのではなかろうか．もし，いくつかの原画がイメージにとっても自分にとっても大切であったとしても，主題が閉ざされていなければ，私は生涯をかけて再び挑戦しただろうと思う」と自省的に語っている．

ジョエル・ステュワート「魯山人」（水彩，1996年）
ジョエル・ステュワート「霧が晴れた」（水彩，1996年）
ジョエル・ステュワート「壷」（水彩，1996年）
ジョエル・ステュワート「振り返る」（エッチング，手彩色，Ed.67，1994年）
ジョエル・ステュワート「浮き世」（エッチング，手彩色，Ed.95，1992年）

Joel Stewart. *Floating World*. Etching with handcoloring. Ed. 95. 1992

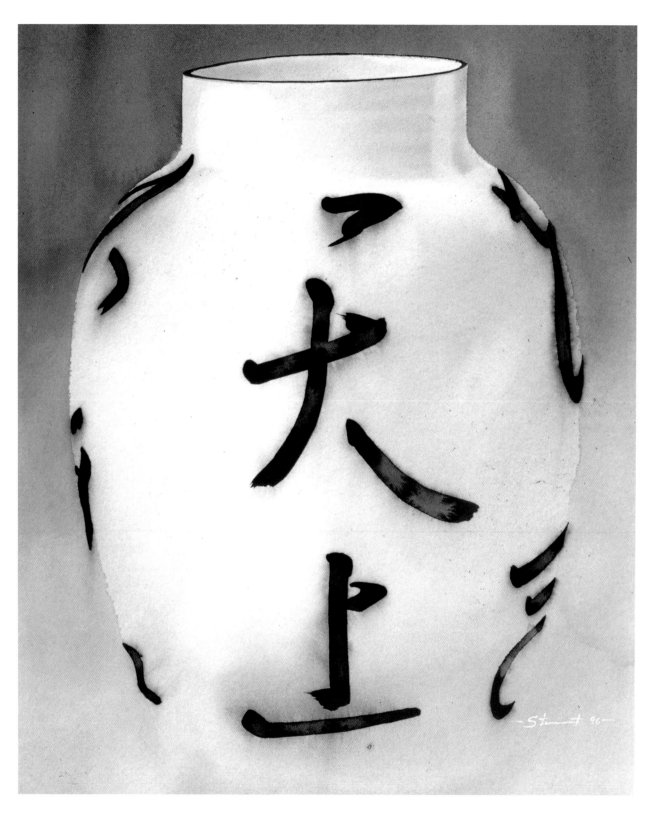

Joel Stewart. *Rosanjin*. Watercolor. 1996

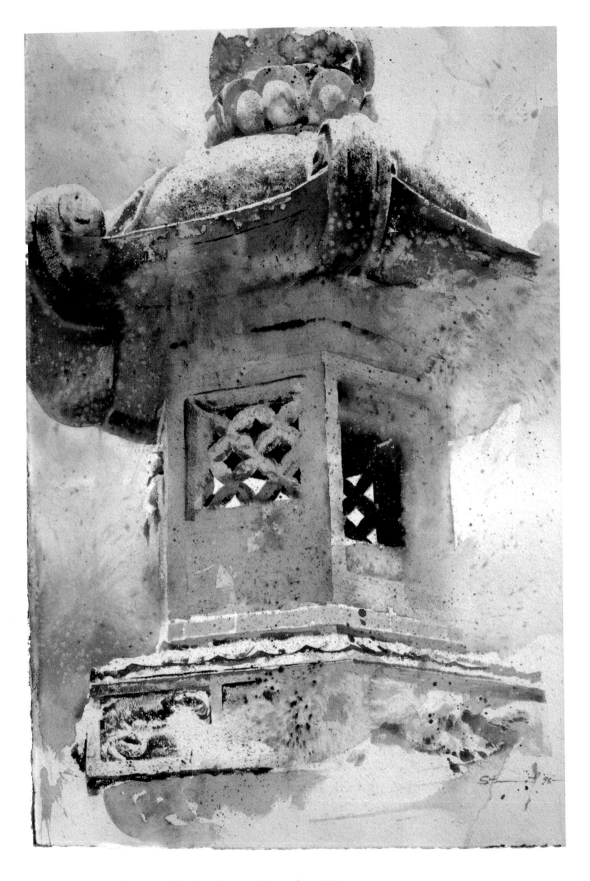

Joel Stewart. *Kiri Ga Hareta*. Watercolor. 1996

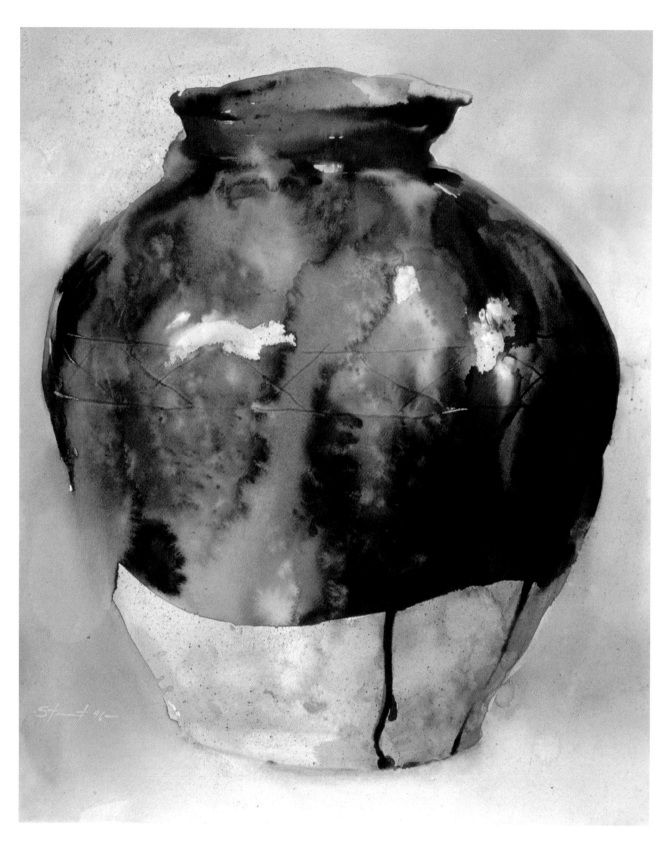

Joel Stewart. *Tsubo.* Watercolor. 1996

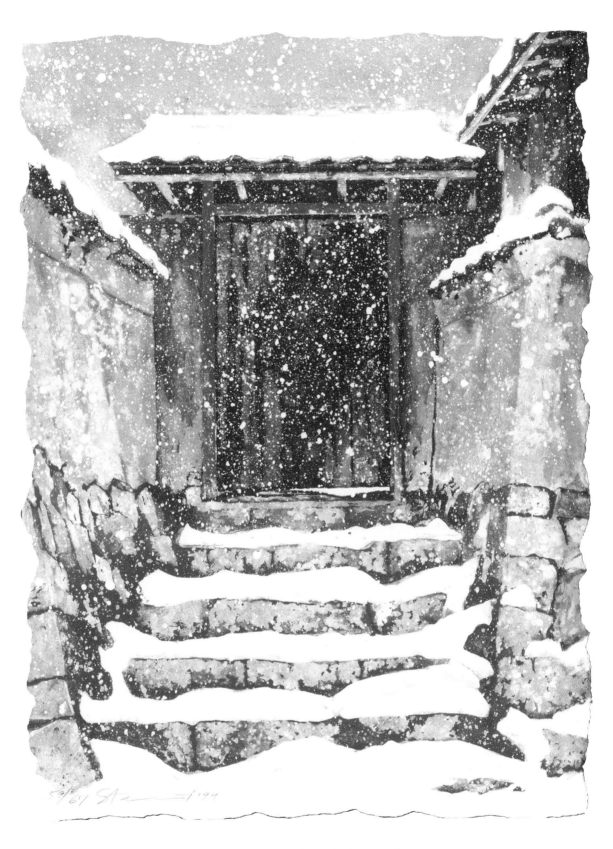

Joel Stewart. *Looking Back.* Etching with handcoloring. Ed. 67. 1994

I was looking for an artist who could capture the feeling of the old Japanese landscape woodblock prints when I received my first shipment of Carol Jessen's work. At the time, several of the other artists I represented had moved away from traditional imagery. Carol did all her own carving and printing, and her work was as appealing to me as the Japanese prints from the nineteenth century and the 1920s and '30s. Her understanding of the use of light and shadow was immediately apparent.

Carol learned the art of woodblock printing during three of her four stays in Japan, between 1979 and 1989. She remembers these visits as a very romantic time of her life.

"I romanticized the culture. Everything was aesthetic. Though growing up in the San Francisco Bay area offered exposure to the Asian culture, I still found myself overwhelmed by the idiosyncrasies of Japan. Peeking down a small alley would reveal an ancient gate, a small garden, or a family altar. Taking a bath in Japan has a whole mystique about it, particularly if you go to the public baths in most urban neighborhoods. The nightly ritual gave me an inside view of a more relaxed, social side of Japan. At first I felt self-conscious while bathing. Women discreetly stared at me as if I were a foreign object invading their privacy. I, likewise, stared back at them, studying their use of the buckets, benches, and small towels modestly covering their private parts, washing and finally submerging into a tub sometimes big enough for an army. Male voices could be heard echoing from behind steamy walls separating the two sides. These images, feelings, and sensations would all come into play when composing future paintings and drawings."

Carol met many people in Japan, including a number of American artists who were to become her friends—

Sarah Brayer, Daniel Kelly, Brian Williams, and Karyn Young. Carol laughs when she relates that the Japanese people weren't as used to foreigners when she first arrived—especially foreigners with blue eyes and blonde curls. People would approach her on the street with scissors, wanting a piece of her long hair.

On her first trip, in 1979, a friend who was studying with a grand tea master was able to arrange for her to stay at an English school called Ishikawa, where many foreigners rented small three- or four-tatami-mat rooms. (One tatami mat measures about three feet by six feet.) She had always wanted to go to Japan to study woodblock printing, and this was her opportunity. Although Carol was unable to find a Japanese teacher, an American artist, Richard Steiner, offered to introduce her to woodblock printing—in black and white only. After eight months, her visa had run out.

"I felt like I had to return to America," Carol says. "I loved Japan but felt stressed out by the fast pace of life. At one point, I was teaching twelve English classes, from preschool children to highly educated doctors and engineers. Teaching at the girls' high school was the most difficult. I never knew whether they were laughing at me or just being giggly schoolgirls. Until I bought my motor scooter, I would ride my bicycle to all the outer reaches of Kyoto, sometimes through rain and snow storms."

Back in California, she resumed her job as a graphic designer. She had acquired the basics of woodblock printing in Japan, but she still didn't know how to print in color or how to register the print so that the color would line up correctly. By saving her money for several years, Carol was able to return to Japan in 1982. This time she stayed in the Japanese Alps, where she studied with Toshi Yoshida, the son of Hiroshi Yoshida, the most important landscape printmaker from the early 1900s. Toshi Yoshida had converted a grammar school in a mountain valley into an active art center, the Miasa Bunka Center. For six weeks, Carol studied intensively with Toshi Yoshida's professional carvers and printers.

"Toshi Yoshida is a very soft-spoken, gentle man," Carol recalls, "He speaks excellent English and has traveled all over the world. He's the kind of teacher who will go to the hot springs with his students, eat peaches, and sing 'Santa Lucia.' He is very kind, and generous with his knowledge."

Carol returned to the Alps in 1984 for a second course of study with the master. It was at this time that she resolved to quit graphics and become an artist full time.

"It wasn't until 1985 that I did my first woodblock print on my own," she continues. "The process is so complicated, I was intimidated by it. But I rented an $85-a-month studio and dove into it."

The results were exquisite. "Reflections," awash in purple, shows two women seated before a lotus pond early in the morning as the buds begin to pop open. Carol also did a series of prints based on her hometown of San Francisco. In "The Promenade," which shows the waterfront, umbrellas are slanted like those of a Hiroshige print as people fight the sheets of rain. Other favorites of mine are "Golden Gate Fog," and "Slick Tracks," which shows cablecar tracks on Market Street.

Her images are very calming—perfect for my gallery—and Carol describes a serenity she can feel at times when producing her art. "When you're doing something artistic, you let go of all the normal burdens, the conscious thoughts," she says. "It doesn't happen all the time, but when I'm concentrating, I'll drift into that. It's better than therapy. It is therapy. You can let go of whatever you normally think about yourself. Your fears, your dreams, you forget it all."

From San Francisco to Kyoto to New York to the south of France and beyond, Carol has traveled ever since she was a teenager as a way to expand her horizons and build a repertoire of images. She admits, however, that her childhood was very different from her present lifestyle.

"My parents and two brothers were supportive and sympathetic but unfamiliar with the kinds of challenges and exposure I needed as an artist," she explains. "I don't think I went to a museum until college. I had no exposure to travel and culture, with the exception of my mother transporting me from one dance class to another. At a certain point, I rebelled against the mediocrity of life. I wanted culture. I wanted travel. I wanted to see what the other side of the world looked like." True to her convictions, Carol put her foot down at eighteen.

"After my first year of college," she says, "I got a loan. I told my mother I was going to use it to go to Europe, and I went to every museum there. I stayed three months. As a kid, I never went to plays or operas. I made up for it!"

At twenty-four, after graduating from San Francisco State with a major in biology and journalism, she put on her backpack again and took a yearlong trip around the world accompanied by a boyfriend, a professional photojournalist.

"I arrived in Lahore, Pakistan, one morning and came to the realization I wanted to be an artist. We were staying with an American schoolteacher whose home was full of batiks and Indian paintings. It was magical. Each day of the week I stayed, I would sit and study one of those paintings. I decided, When I go home, I'm going to learn how to do that.

"I was always artistically inclined as a kid," she adds. "But I got thrown out of an art class in eighth grade. I got into a fight with this guy. He destroyed my art project and I decided never to take another art class."

Fortunately, Carol didn't allow her past experience to keep her from art. After traveling around the world, she returned to San Francisco and began classes at the Academy of Art College. She also attended an open-studio sketch class at the San Francisco Art Institute. There she met a fellow artist, Bill Lansberg, who encouraged her and taught her how to recognize the differences between looking at an image and designing an image. She learned from him many aspects of the psychology of perception that helped her understand the use of visual cues in a composition. He escorted her to many art exhibits, bookstores, and libraries, here and abroad. Her constant companion for twelve years, he continues to be a close friend who still critiques her work.

Over the years, through her experiences and her successes, Carol has gained confidence when faced with a white piece of paper: "It's a challenge. It's threatening. It attacks your ego.…It's a challenge to come up with interesting compositions. A lot of great artists have come before me. I love Degas—I love his compositions. And Cézanne, of course. But I always feel there's room to do something totally my own. That's what I'm striving for."

Carol does her work at Hunter's Point Naval Base in San Francisco, which has been converted into a community of over three hundred artists of all kinds. Carol was one of the original tenants—the third to be exact. She has been there for ten years. When I went to San Francisco to visit Carol, I had to check in at the security office, show my pass to the guard at the gate, and navigate through a maze of whitewashed hallways to find her. I couldn't help thinking about my father, who had been stationed at Hunter's Point in 1945.

In the studio, I watched Carol demonstrate the ancient art of Japanese woodblock printing. She showed me how she carved portions of the image "Ecce Panis," a specially commissioned print for the University Print Club of Cleveland. She brought out the eight wooden blocks used to make the print. She said most people think the hard part is registering (lining up) the print for each of the twenty-six impressions needed for the image. But actually, most of the time and energy is spent on planning out the blocks, the physical labor of handprinting, and the proofing of the colors.

"It's all very carefully thought out before the image is transferred to the block, and carefully proofed to correct the color before editioning begins," she says. "The powder pigment used is water-based and transparent. Therefore, if the wrong color is used on the twentieth step, I've got to go back to the first step and start all over again. Both the imported Shina wood and the handmade paper ($36 a sheet) are very expensive, due to the low value of the dollar. Fortunately, it wasn't that way in 1979. Otherwise, my destiny might have been slightly altered."

Carol says frankly that she hates the process. "It's tedious, time consuming, frustrating. I'd rather be working directly with my oil paints or pastels, but when the final print is done, it's worth all the effort."

Sometimes I wonder if Carol really knows how skillful she is as a woodblock printer. She is one of the few people in the United States who can make woodblock prints in the

traditional way. Most of the others, for instance, use a spoon, rather than the traditional baren, to rub the back of the print when transferring the water-based inks onto the paper.

Of the labor, she says, "Just physically, if one person is doing the brushing on of the color, it takes a lot of physical strength. Using the baren also takes a lot of muscle, to get enough pressure to force the watercolor into the fibers of the kozo paper. When I'm really into my woodblock printing, don't mess with me in a dark alley!"

During Carol's one-woman show at my gallery in Cleveland, she exhibited woodblock prints along with pastels and oils. Two of the prints on display have been accepted into the collection of the Cleveland Museum of Art. "Kozo," which means mulberry, shows the kozo lady, who is the first person in the papermaking process. She is shown separating the pulp from the bark of the kozo tree. "The Paper Makers" shows a later stage when the pulp is placed in large vats and covered with water.

Carol explains how she became inspired to do this series: "While in Japan, I went into these rustic old papermaking factories. There were big vats of pulp fibers. People would throw them on the molds. It looked like rolling big sushi. The natural light shining through the window cast a beautiful sheen on the wet paper. There were reflections on the ground from water splashing on the floor. I came away with powerful imagery in my head."

Sitting in her studio, Carol explained that she has adapted well to her lifestyle as an artist. "Obviously, nobody's totally autonomous. At least I have some control over my destiny. It's a bit insecure—as an artist you're living on the edge. But I'm used to insecurity. During the good times, I've managed to save enough money to pull me through the leaner times. I like the idea of being able to do what I want when I want."

She goes on, "I also like the idea that it's always evolving. Hopefully I will never be comfortable, which is an uncomfortable thought. Life as an artist is constantly offering opportunities to grow, to learn. I would die if I had a nine-to-five job again."

It is clear that Carol's artistic journey has given her a clear sense of herself when she comments on her style: "The postmodernists might say I'm not doing anything new, I'm not saying anything. Well…I don't care. I have no political agenda. I'm not trying to change the world or influence anyone. My aim is to participate in a creative process that expresses something uniquely beautiful, hopefully aesthetic, and allows others to enjoy it. It's entirely self-motivated and I can't be laid-off by downsizing. This would be considered a bright future by anyone.

"Part of the reason I became an artist is I didn't know what else to do with my life," she says. "Through art, I figured out who I am and where I'm going."

キャロル・ジェッセンはカリフォルニア州オークランドで生まれた．彼女は「平凡な生活」に嫌気がさし，もっと創造的なものを熱く求めて，バックパックを背に世界中を歩き，1979年から1989年までの10年間はたびたび日本を訪ね，吉田遠志の下で木版画を学んだ．吉田遠志は，1920年代から30年代にかけて風景版画家として名を馳せた吉田博の息子である．キャロルは伝統的な技法で木版画を製作できる者としてはアメリカでも数少ない一人であり，現に彫りから刷りまで自分で行っている．その作品は光と影の交錯を特徴とし，古い日本の木版画の感覚を備えている．彼女は自身が作品製作に当たっているときの心安らぐ思いを次のように語っている．「人はなにか芸術的な創作活動を行っているときは，あらゆる悩みや自意識過剰から解放されるものです．医学的治療よりも効果的だし，それ自体が一つの治療法でもあるわけです．自分自身についてあれこれ考えることから解放されるのです．恐れも幻想もまったく忘れてしまいます」．

キャロル・ジェッセン「パン屋エケ・パニス」（木版，Ed.50，1995年）
キャロル・ジェッセン「朝霧」（木版，Ed.20，1982年）
キャロル・ジェッセン「紙漉き」（木版，Ed.75，1992年）
キャロル・ジェッセン「楮」（木版，Ed.75，1994年）
キャロル・ジェッセン「影」（木版，Ed.70，1985年）
キャロル・ジェッセン「ヴィレット・ライブ・アート」（木版，Ed.80，1996年）
キャロル・ジェッセン「遊歩道」（木版，Ed.55，1986年）

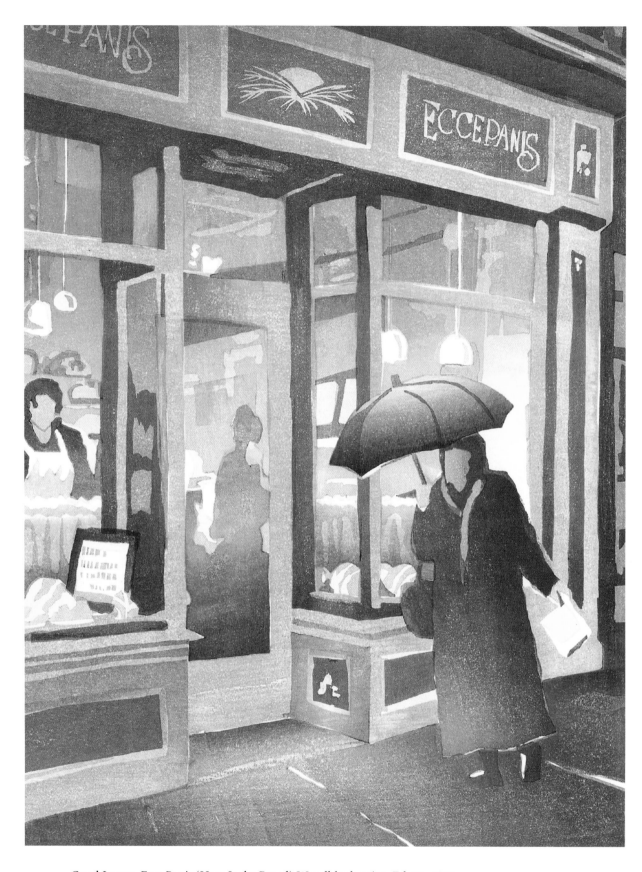

Carol Jessen. *Ecce Panis* (Here Is the Bread) Woodblock print. Ed. 50. 1995

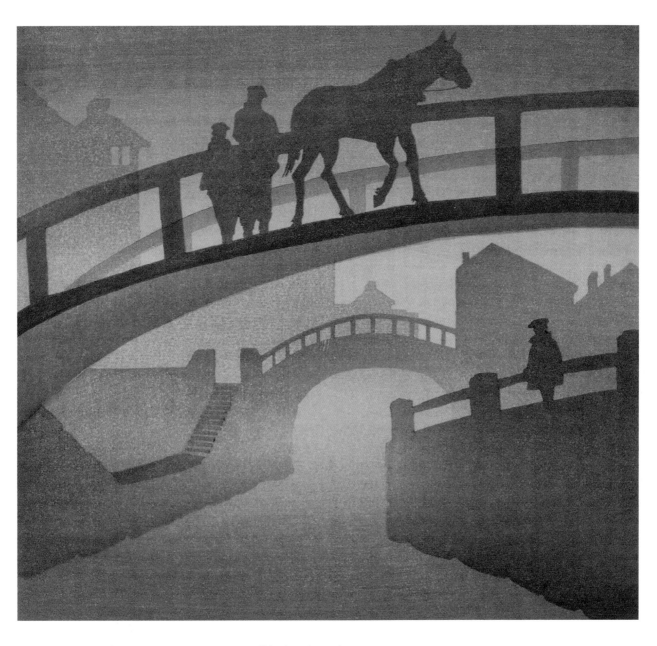

Carol Jessen. *Morning Mist.* Woodblock print. Ed. 20. 1982

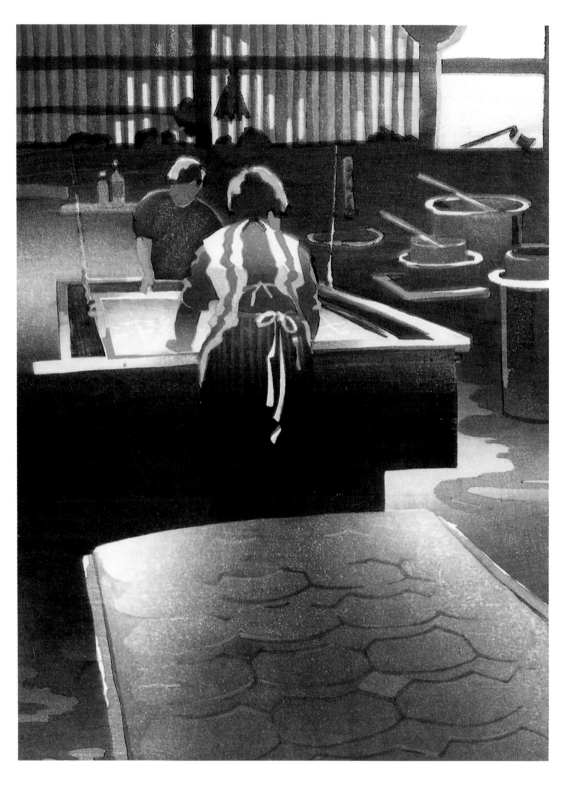

Carol Jessen. *The Paper Makers.* Woodblock print. Ed. 75. 1992

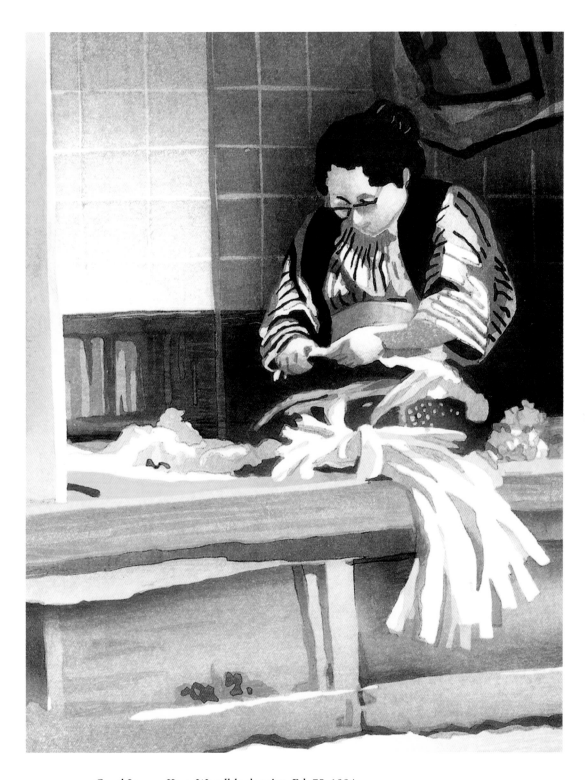

Carol Jessen. *Kozo.* Woodblock print. Ed. 75. 1994

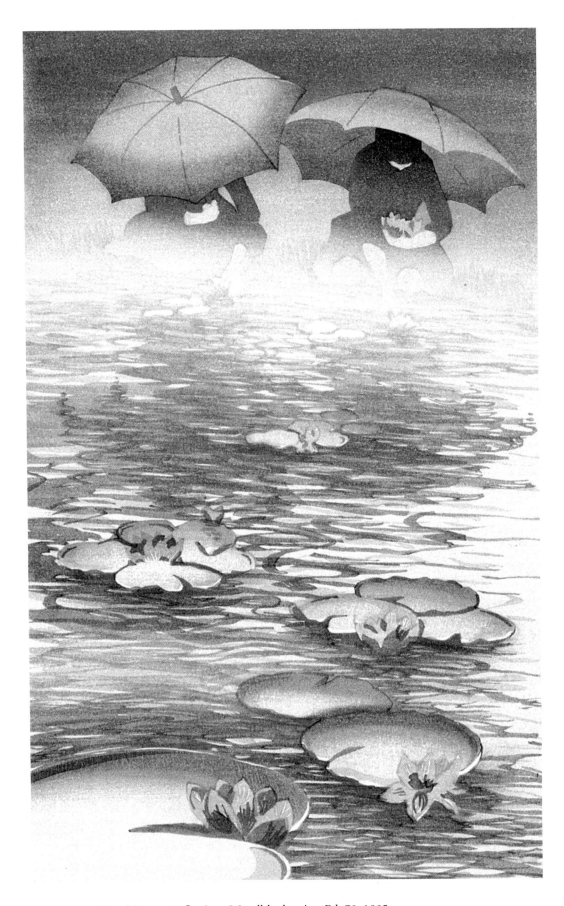

Carol Jessen. *Reflections.* Woodblock print. Ed. 70. 1985

Carol Jessen. *Villete Live Art.* Woodblock print. Ed. 80. 1996

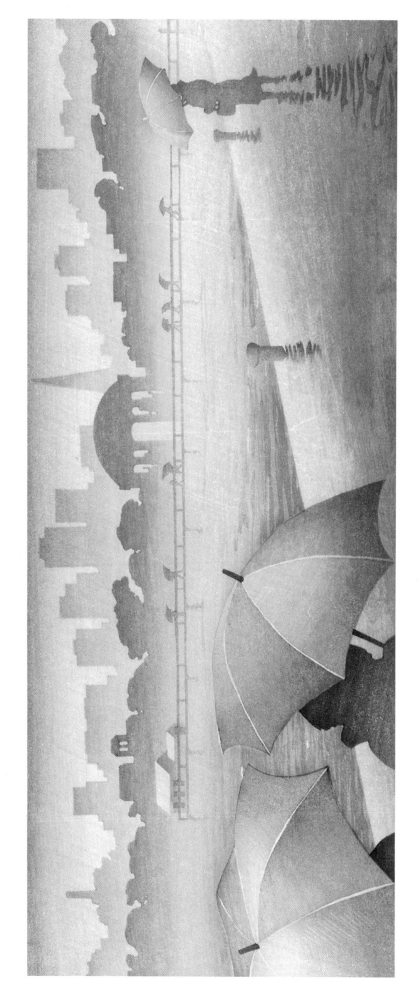

74

Carol Jessen. *The Promenade.* Woodblock print. Ed. 55. 1986

I t takes time to get to know a place well enough to be able to really paint it," Brian Williams says. "You've got to build up the knowledge, the experiences, and the emotions about it, and develop a pictorial vocabulary to express them."

When I visited Brian in the fall of 1995, I was able to see for myself the places that he has gotten to know so well. For the past eleven years, Brian, his wife, and his three daughters have lived in a one-hundred-fifty-year-old Japanese farmhouse on the outskirts of Kyoto, near Lake Biwa.

As we drove up to the house, Brian explained that the neighbors were interested and intrigued "when a foreigner bought old Kichigoro's place" and began remodeling it with the help of carpenters. He told me how he had designed the small, Japanese-style garden in the front of the house and the rustic picnic table made from two big slabs of Japanese cedar. He pointed out the vegetable garden "awash in weeds" and the pine tree that he's been pruning and shaping for years. His goal, he said, was to return the roof of his house to thatch someday.

I recognized the multilayered mountains and the foothills that form the backdrop of many of Brian's paintings and admired the soft-green rice paddies that border his home and his studio nearby.

Of his studio, Brian said, "I have a Tunisian handmade rug and a wonderful, but somewhat worn, sofa. A stereo. Piles of books everywhere. Piles of watercolors, and all these damn millipedes!"

In fact, when I had telephoned Brian earlier in the year to gather information for this book, I was unable to get through because of the millipede invasion. At the time we had agreed to talk, Brian had been sweeping the creatures—"with their ripples of legs on either side"—from the studio ceiling and had inadvertently knocked the telephone off the hook. It wasn't until his wife woke him from a catnap on the sofa that I was finally able to reach him.

BRIAN WILLIAMS

Brian's studio, on a neighboring farmer's property, is a convenient five-minute walk from his home. When he and his family first moved in, the farmer took them under his wing. "This farmer had a shed for farm-tool equipment and had built a second story on it," Brian said. "His sons had a little batting cage up there. I got a job painting a string of camels walking across the desert. It was a large commission, and the farmer said I could use the space. First I rented half the space, then all but the corner, then all of it."

Brian works both in the studio, on his etchings and large oils, and outdoors, where he does all but the finishing touches on his watercolors. He explained to me that things can get somewhat chaotic since he is not bound by a regular schedule, but his objective is to free himself from distractions and to paint whenever possible. He even goes so far as to paint while talking on the telephone.

"If I go three or four or five days without it," he said, "I feel irritable, antsy, like something's wrong—just like sex, except more so."

"For painting on the spot, I use watercolor," he continued. "It is my first love. Water-

color has been at the very center of my art since I first realized I was going to be an artist. With watercolors, I can stand outside and watch the progression of a day. Fishermen have that too. They have an excuse. If you're there painting, you can watch the day go by. Most people end up inside for supper or inside for breakfast at the sunrise and the sunset, when the light is mysterious and richly colored. It's beautiful beyond any power of human description, but some of the emotion can be distilled on paper."

Of course Brian was quick to explain that it's not always as romantic as it sounds. "Painting outside the studio is challenging not only because it is hard to keep up with the steadily changing light, but also because of the little things: mosquitoes, snow storms, or sudden rain squalls, barking dogs and snakes. Or else, curious onlookers and critics, policemen and landowners, diesel exhaust, mud to sink into, falling rocks."

"I have painted watercolors by moonlight, by flashlight, when the temperature is turning the paints to ice, when the wind is seriously trying to snatch away palette, paper, and brushes, in entertainment districts at night while fending off happy drunks, on rooftops of buildings without permission. I find all this an excellent antidote for boredom and for all the mannerism and uninspired repetitiveness that a painter can fall into by spending too much time in the isolation of a safe and comfortable studio."

Brian's work shows no signs of such boredom. In 1990, when Daniel Kelly brought a few of Brian's small etchings to the gallery, I could see that Brian was able to convey a great deal of the emotion he felt in nature onto the paper. His imagery was stunning. The thing that differentiated his work from that of some of the other artists I represent was the realism and the detail. In fact, his paintings and prints showed the influence of both Turner and Andrew Wyeth. After running across more of Brian's work in the CWAJ catalog the next year, I was certain I wanted to represent him. But finding him was an adventure in itself. I wrote to the committee chairman of the *CWAJ Journal* and to Daniel, but it wasn't until a year later that I received an unexpected telephone call.

"This is Brian Williams," the caller said. "I saw Daniel Kelly on the streets of Kyoto, and he said you're looking for me."

Over the next year, Brian sent me many examples of his work. He was constantly experimenting with different techniques and media—watercolors, monotypes, etchings, oils, and lithographs. I found his monotypes intriguing because he has a special method, using his handcranked proofing press, that enables him to do a series of monotypes of the same image, rather than creating just one.

"A print is like an identical twin—one print to another," Brian explained. "These 'series monotypes' are more like siblings. You can tell they look alike, but they are different, too."

"Evening Song—Katata," his most popular monotype in the gallery, captures the pink hue of early evening, with the setting sun reflected in Lake Biwa. I particularly like this work because it has a looser feel than some of Brian's watercolors and oils. "Yuki No Hi" (Snowy Day)," one of the largest watercolors he has sent me, is a landscape with an old farmhouse similar to Brian's home. People often comment that it is the most remarkable watercolor they've ever seen. Another painting, "Boka Yosui (Firewater)," also gets a lot of attention from visitors. Reminiscent of Wyeth, the painting shows a rusted waterbarrel that was used to hold emergency water during the war. It is now full of rakes that are so beautifully rendered they look almost like a Japanese flower arrangement. "Snow Light," an etching of a farmhouse in winter, shows what Brian can do in black and white. Many people have chosen to add this small, very affordable etching to their collections.

As appealing as Brian's subject matter is, he explained to me that it is not so much

the objects that he is painting, but the light and the air around those objects. This has been his focus since his earliest days in Japan.

"When I was studying ink painting, an old painter said, 'Don't paint the object. Paint the air around it.' I used subtle wash after subtle wash after subtle wash," Brian said. "I've never forgotten what he said."

Over the years, by playing with the subtle gradations of color and the grays within every color, Brian has been able to produce paintings that seem to glow. When describing his watercolors, he said, "The layer of paint is so thin, it becomes one with the paper it's painted on. You can get a luminous quality, where some of the light is reflecting off the white of the paper beneath, as if you turned on a soft light behind the paint layer. It's always something of a miracle, this glow that seems to come from a piece of paper that actually has only a limited range of light and dark values.

"What I try to get in my paintings is a clear sense of light, a light that unifies everything in a real scene and should in the painting, too. I believe intuitively that light is the closest we can get with our senses to knowing the energy that animates the universe. A painting that glows with a sense of real light is a painting that has magic and mystery in it. But, to get your paintings to seem as if they glow can be a hell of a problem."

One of the challenges Brian has taken on is to paint those "lovely soft moments between night and day. It is not so easy. The light and colors change so fast, and you often have to paint in dim light, with mosquitoes whining in your ear. And the watercolor paint won't dry on the paper, slowing you down even further, or so I used to think." One day, he got the idea of using a plumber's torch to dry the paint as he worked. Ever since, he has been able to work "almost fast enough to keep up with the changing light."

It is only natural that a landscape painter like Brian, who has always had a serious interest in marine biology, is deeply concerned about the environment. He participates in demonstrations, he lectures, and he paints.

"The beauty of a scene is the indication of its health as an ecosystem," Brian said. "The more degraded a stream gets, the uglier it gets to a painter, the less it works as a biofilter, and the worse the quality of the water in it."

Kurt Vonnegut, Jr., said that writers are like canaries in a coal mine. Brian thinks this is also true of artists' reactions to the destruction of nature. "Artist types are more sensitive than the average person—they can't claim credit for it, it's just the way they were born or brought up—so they start showing signs of distress before the rest of the population."

Nonetheless, Brian says emphatically that he doesn't use his paintings to send a political message. "I feel strong emotions when I see a beautiful scene. It's a form of love," he said. "My response is to try to convert that into a painting, but I can't use painting as a propaganda tool. If, in the process, it makes an environmental statement, that's a side effect."

Over the past several years, as I've gotten to know Brian better, I've learned not only about Brian's philosophy, but also about his personal history. He was born in Lima, Peru, and lived in the Andes with his missionary parents. At the age of twelve, his family moved to the northern coast of Chile, a few blocks from the ocean. As a boy, he spoke both English and Spanish and developed an appreciation for other cultures.

"My South American experiences gave me a love of natural beauty and a wanderlust that will never die," Brian said.

When Brian reached the eleventh grade in his Chilean school, which had rather limited facilities, his parents sent him to Redlands, California. He was released from the language requirement and replaced his Spanish class with an art course.

"Three months later," he said, "I realized I was going to be an artist—it was more of a realization than a decision. To know what you want to do with your life at the age of sixteen! I got really lucky."

Brian went on to study art at the University of California at Santa Barbara. He refers to this phase of his life as "my education, California-style."

"I got my higher education from 1968 to 1972, a time of ferment and confusion and resentment. College kids were searching for new and different ways. It was the age of the counterculture—health food, yoga, living in communes, transcendental meditation—everything the previous generation had not dared consider."

In his quest to try to get back to his natural roots, Brian spent time living in a teepee and surfing on the nude beaches near his college. His pursuits at the time also contributed to his interest in Japan.

"Among many things I tried was macrobiotics, eating brown rice and so forth. It led me to other aspects of the Japanese culture, such as aikido. I also wanted to study ink painting and woodblock printing, both of which are water-based. I wasn't interested in studying woodblock printing for its own sake, but rather to see how it might relate to watercolor," Brian said.

At the same time, he had looked at the New York art scene and found it lacking.

"It was a lot of mental fun and games, but it didn't go very far," he said. "I thought the Western art tradition had dead-ended in a fashion fair, where the only values were novelty and a certain conceptual wittiness. I was two months from graduation, with an A– or B+ average when I dropped out and built a camping van to go to the Southwest and paint. But a girlfriend was going to Japan, so I sold the van and agreed to go to the Orient. Why not go to Japan? I was very poor and I could make a living teaching English. I bought a one-way ticket and arrived in Japan on September 1, 1972, with $300 in my pocket. And I never came back."

As it turned out, Brian felt very comfortable in Japan, partly due to his experiences growing up in Peru. In both cultures, he said, "the people have an initial reserve, it takes a greater commitment to be a friend, and they are not as direct as Americans."

One year overseas turned into two, two into three. In 1975 he married his Japanese wife, Hidemi. As well as teaching English and doing technical English-Spanish translations, he spent as much time as he could painting and making etchings. Little by little, through small one-man shows, private gallery showings, and commissions, he built a career. When he was twenty-eight, he was able to devote himself solely to his art.

Brian's fluency in the language, his understanding of the culture, and his being an American artist "to boot" provided an entrée into the Japanese world, enabling him to meet many Japanese people. He also developed a circle of friends from the diverse expatriate community in Japan.

Since his first major one-man show in Kobe in 1978, Brian has become one of the leading American artists in Japan. Since 1981, he has had over thirty shows at Takashimaya department stores, which are among the most prestigious art venues in Japan. His work is currently in the collections of the British Museum, Cleveland Museum of Art, the Cincinnati Art Museum, the Oregon Art Institute, and the Museum of New South Wales.

But Brian's success story is only a part of the whole picture. Brian is a gentle soul. His modesty and his kindness were evident the first time I met him. Brian's view of his own success and his explanation of why he paints help explain his unassuming attitude.

"As a professional artist, I make a fairly decent living. This is a wonderful thing to have happened. I don't just paint for a living, I paint for a life," he said. "I paint to get in touch with infinity and the whole mystery and the permanent essence behind all the things that are impermanent. And of course, there's the simple satisfaction of making things with your hands."

He also admits that basically he is a junkie, and painting is his high.

"I feel really alive when I'm painting well," he said. "When you make the right strokes, with the right color, the right touch, there is this sense of being a participant and spectator in a lovely and inevitably unfolding event. Once you discover that mental/spiritual/emotional place, you want to get back there. That's the addiction."

For me, representing this very successful artist was a challenge. Basically, he had entrusted our small gallery in Cleveland with the responsibility of representing him across the entire United States. Although we are one of the leading Japanese print galleries in this country, I had to warn Brian that initially our sales would not match those of his well-established Japanese market. To my surprise, he was very humble and shared my philosophy that the relationship between artist and gallery has to be based on friendship first.

During the summer of 1993, Brian came to Cleveland to help me plan his one-man show in Cleveland for the spring of 1995. Most people have no idea how much work is involved in planning a show for an artist. In Brian's case, I began by taking his work across the country to the many works-on-paper shows in order to determine which pieces would appeal to collectors. In the two years that ensued, collectors in the United States became aware of Brian's talents. As the show neared, everything was ready except the three large watercolors that were the centerpiece of the show. Unfortunately, Brian's mother had passed away early in 1995, and he was understandably having difficulty meeting his commitments. Only two days before the show, the paintings were not completely finished, but Brian assured me I had no need to worry.

At the airport the day before the opening, Brian was nowhere to be seen in the baggage area. I nervously went to check my car for a parking ticket. When I returned, I was delighted to see a large wooden crate coming down through the baggage conveyor belt. And there was Brian, casually walking toward me with his friendly smile. The show opened that night with great success. Over a few beers, Brian and I toasted his continued success and our growing friendship.

Brian's life is a work in progress. As he says, "I want to die with my memories, not my dreams." To that end, he and his eldest daughter climbed Mount Kilimanjaro together in 1993. With his art supplies strapped to a camel, he hiked across the Takla Makan Desert in western China, one of the first two Americans to do so, as far as he knows. He has been trekking on four occasions in Nepal, where he climbed Island Peak, visited Everest Base Camp, and painted Mount Everest by moonlight. In 1995, he was helicoptered off the mountain due to a knee injury. From his home in Kyoto, he learned that the rest of the group had perished in an avalanche several days after his departure.

Brian's venturesome spirit also manifests itself in his approach to his artwork.

"Painting becomes a dialogue once you make the first mark on the paper," he said. "It's an unending adventure because there's always a new discovery and your work is always leading you to it."

Summing up his feelings quite simply, Brian said, "When my eyes are open, I'm never bored. If I'm outside somewhere with easel and watercolors, that's the happiest I get."

ブライアン・ウィリアムズはペルーのリマで生まれ，16歳までその地で過ごした．高校はカリフォルニアで終え，1960年代にカリフォルニア大学サンタバーバラ校に入ったのだが，ちょうど反抗期の年齢であった．それで，多くの芸術家がヨーロッパへ勉強に行くことを知りながら，彼はポケットに300ドルを入れて1972年に日本へ行き，結局そこを離れられなくなってしまったのである．彼とその家族は農家を改造した家に住んでいる．この家は，彼の版画や水彩画に非常に美しく再現される主題の一つでもある．だが，それはそれをとりまく光と空気ほどの主題ではない，と彼は言う．現実の画家の中では，ブライアンは高島屋百貨店で30年以上にわたってその作品が展示されてきた最初のアメリカ人である．自身の仕事については，次のように語っている．「ふさわしい色としかるべきタッチで正しい筆遣いをすれば，そこには愛すべき納得のいく結果が生まれ，自分がその協力者でもあり鑑賞者でもあるのだという感覚が生まれるのです」．彼の感覚を要約すれば「目をあけていれば，退屈することは決してありません．画架と絵の具を持って野外に出れば，至福が得られるのです」ということになるだろうか．

ブライアン・ウィリアムズ「防火用水」（油彩，1992年）
ブライアン・ウィリアムズ「雪の朝」（エッチング，Ed.180，1996年）
ブライアン・ウィリアムズ「雪明かり」（エッチング，1994年）
ブライアン・ウィリアムズ「雪の日」（水彩，1995年）
ブライアン・ウィリアムズ「夕唱」（モノタイプ，1996年）
ブライアン・ウィリアムズ「雨後」（水彩，1991年）

Brian Williams. *Boka Yosui* (Firewater). Oil. 1992

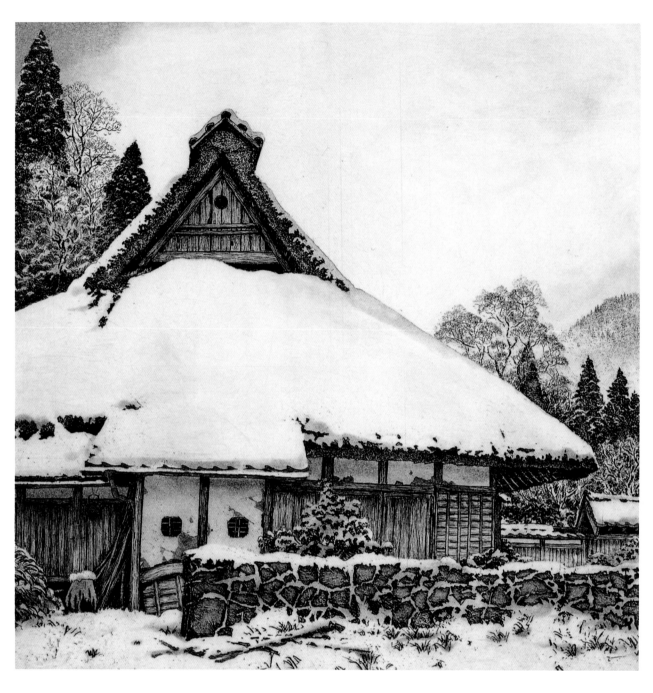

Brian Williams. *White Morning.* Etching. Ed. 180. 1996

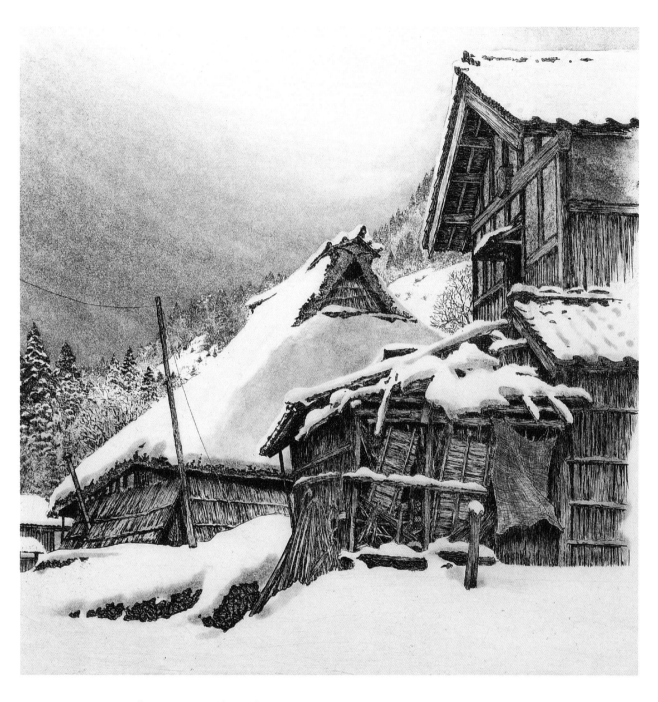

Brian Williams. *Snow Light.* Etching. 1994

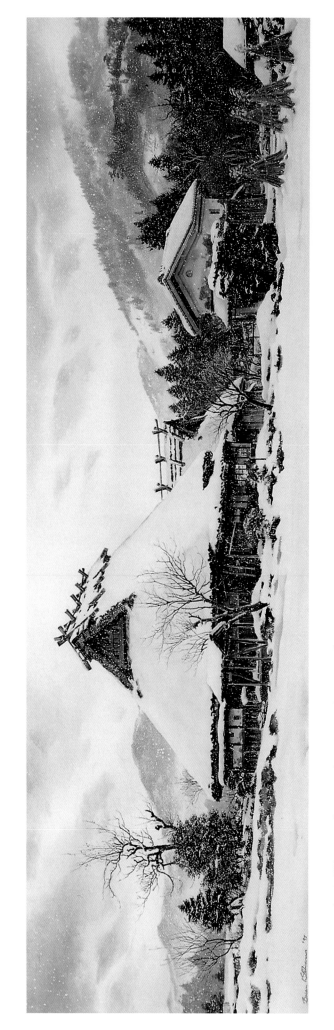

Brian Williams. *Yuki No Hi* (Snowy Day). Watercolor. 1995

84

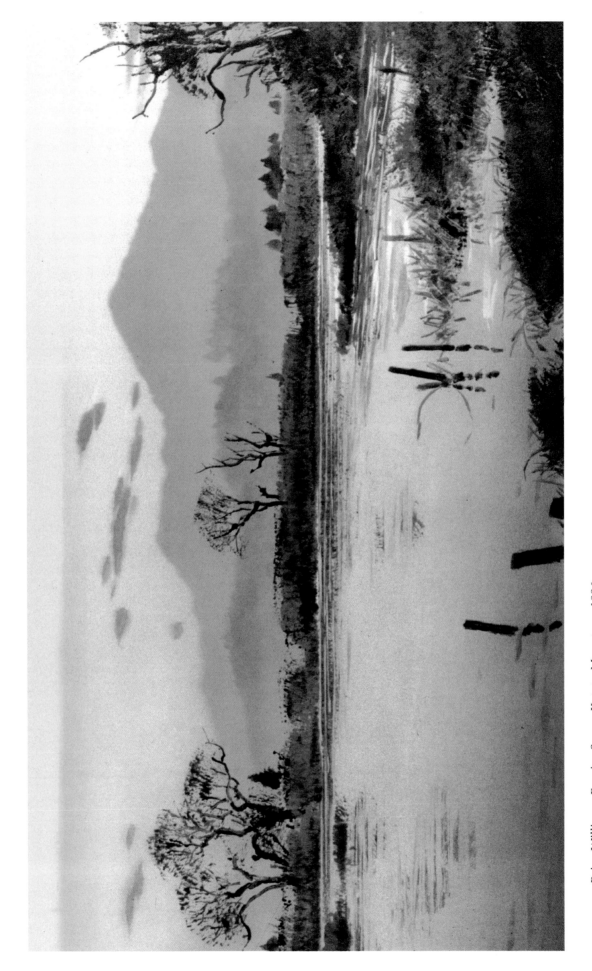

Brian Williams. *Evening Song—Katata*. Monotype. 1996

Brian Williams. *After the Rain.* Watercolor. 1991

S arah Brayer's work has charmed me ever since I ran across her prints in a Ronin Gallery catalog in 1987. Her work has an indescribable emotional appeal. The subject matter of her early prints is Japanese in nature, yet any viewer can easily relate the imagery to events and feelings in his or her own life.

Presently Sarah is still creating etchings and aquatints, but she has also become deeply involved in making paperworks, a process in which an image is formed by pouring pigmented paper pulp onto a bamboo screen. The pulp is manipulated not with brushes, but by tilting the screen, spraying it with water, and using the hands as a drawing tool.

Sarah describes her creative process as "leaping into the unknown and finding your footing." Through a series of such leaps, Sarah has gone from being a talented, successful American artist living in Japan to someone who has found a unique style and has taken her skill to a new level.

Born in Rochester, New York, Sarah studied art at Connecticut College. "When I was in college," Sarah said, "I did quite a bit of pottery, especially raku yaki. I don't know how aware I was at the time, but when I look back, there was a Japanese aesthetic I had a natural attraction to.

"I came to Japan in November 1979, right after I graduated. I thought it would be a trip of several-months' duration. The timing was important for me. I had spent four months of my junior year in London making prints, and I came back to the States wanting to live abroad as an artist again. Being in a different culture allowed me a certain freedom in my work. I could look at things from a different vantage point."

Sarah arrived in Kyoto with few expectations. She found a small apartment and was able to set up a working life, teaching English at night and concentrating on her art during the day. By February, a Japanese artist, Yoshiko Fukuda, had opened her etching studio to Sarah.

SARAH
BRAYER

"My first studio was very small—a four-and-a-half [tatami] mat room," Sarah said. "I would etch my plates in the kitchen and take them to Yoshiko's studio to print. That was the beginning of using my Japanese to survive in a practical way, because Yoshiko didn't speak English."

Sarah explained that her subject matter changed at that time due in part to the size of her living quarters. "In most of my work in college I was into interiors and still lifes. I was concerned with perspective and design, and light and shadows. When I got to Japan, I couldn't back up from anything. If I wanted to look at the light coming in the window, at least in the room I was living in, I couldn't get far enough from the window."

The tiny apartment forced Sarah outdoors where she began sketching and painting from nature.

"That was a change," she said. "When you're out in the landscape there's a lot to choose from, and a natural way of editing takes place. Daniel Kelly lived in the same neighborhood, and we would go out and sketch together. Brian [Williams], Daniel, and I would also go out painting in the countryside nearby."

Although Sarah produced some watercolors, she continued to work mainly in black and white in her etchings and aquatints. In 1982, while independently studying woodblock printing in the summer studio of master printmaker Toshi Yoshida, she began to play with gradations of color.

"I started to get into the colors of nature," Sarah said. "My first woodblock print was a landscape of the Kamogawa River. I worked with the subtle gradations of the morning mist as it changed from yellow to peach to pink to violet."

Sarah's experiences with fresh, transparent layers of color in woodblock printing gave her the impetus to use a bit of color in an aquatint of cherry trees she produced in 1983. She introduced pink blossoms into "Blossom Flurry," an otherwise black-and-white print.

"I was getting my nerve up," she said.

Then in 1984, an experience in New York precipitated a turning point in Sarah's work. While in New York for a show at the Ronin Gallery, Sarah met master printmaker Kathy Caraccio at her studio.

"As soon as I walked in the door, I knew I wanted to work with her," Sarah said. "On the walls were aquatints which had the same soft, gradated, transparent colors that I had been working with in woodblock printing. Here it was in aquatint. I thought to myself, 'Aha, this is a kindred spirit.'"

Kathy walked Sarah through the etching of her first color plates. They proofed together, became close friends, and spent a very productive three months working together. When Sarah returned to Japan, she continued using color in her etchings and aquatints. Her experience with Kathy marked the start of a series of annual trips she has made to New York ever since.

"It started the pattern of going to New York to explore new ground and new techniques and to collaborate with other artists—things I wouldn't ordinarily do in my Kyoto studio," Sarah said.

In 1985, another highly significant change took place in her work. "I started taking washi, Japanese paper, and collaging it on top of my watercolors. I used the veils of paper to mist over the watercolors underneath, to make the image soft. I also incorporated washi into my prints as an integral part of the design."

"In 1986 I made a print called 'Soft Edge,'" Sarah continued. "I etched the plates, and then, before printing, I tore up pieces of washi to make the clouds, snow-laden street, and distant trees. I went through about twenty proofings, trying different combinations of paper and inks. In the final edition, there were twenty-four pieces of washi! Although very time consuming, the washi added a soft, feathery quality to the image. And it was a unique solution."

"Soft Edge" was made in New York in the Caraccio studio. Seeing the direction Sarah's work was taking, Kathy Caraccio suggested that Sarah visit Dieu Donné, a paper studio in Soho, the name of which means "God given."

"When I saw what they were doing, I was excited," Sarah explained. "There were all these possibilities with liquid paper pulp. Why just make paper when you could use the pulp to paint with? That was the beginning of working with paper as a painting medium. Ironic as it was, the idea of making large paperworks in Japan came to me while I was working in New York," Sarah said.

Back in Japan, energized by her exposure to paper in New York, Sarah searched for a papermaking facility. She was led to the town of Imadate in Fukui Prefecture, north of Kyoto, near the Japan Sea. Imadate is an ancient papermaking center dating from the

Nara period, around A.D. 800, a time when the Japanese were making fairly sophisticated paper. Today Imadate is one of the most active papermaking centers in Japan, with about ninety families involved in handmade-paper production. Some of the facilities are big factories, and some are small paper mills in the backs of homes.

For the past ten years, Sarah has been working consistently at the Taki Papermill. With the cooperation and collaboration of the resident papermakers, she has developed her own methods of creating paperworks, drawing on traditional Japanese papermaking techniques and materials and infusing them with her own sense of Western improvisation.

Using the kozo (mulberry) and mitsumata plant fibers as pulps, she begins by creating a palette of colored pulps, with each color in a different bucket. A base sheet of kozo is poured onto the three-by-six-foot screen. While the sheet is wet and resting on the screen, colored layers of mitsumata pulp are built up on top, gradually forming an image. The pouring can be quite involved, especially when atmospheric effects are created. In the final stage, the image is removed from the screen, pressed, and dried, making a complete paperwork.

"There is a certain amount of improvisation as I'm pouring," Sarah said. "I try to keep it fluid and not tense up. Radical changes can be made immediately by adding more pulp or spraying it down with the mister. I am able to capture movement, atmosphere, and the fluidity of the present moment.

"It's very different from delicate scratching on an etching plate," Sarah adds. "The pulps are moving around. It's wet. There's a seductive quality that the wet pulp has. It's all very magical."

Sarah explained to me that although the process is rapid in one sense, a great deal of preparation goes into it. There's musing time, and there's time spent designing the piece in her studio. If it's a very large piece, such as a six-foot-square folding screen, she makes a simple pattern out of paper by drawing the piece to scale on her wall. Viewing the design from a distance is an important part of the preparation since the pouring of the paperworks is done on bamboo screens that are horizontal, and the paper is one-by-two meters, the size of *fusuma* (Japanese sliding doors).

"Sometimes I'll climb up on a ladder and look at a piece in progress," Sarah said. "But because there are so many other things to think about—color, pouring, the wetness of things—I try to resolve the design in my studio."

One of the joys of her experience has been working with the master papermakers at the Imadate facility. This team of ten women, who have all been making paper since they were eighteen, are now in their forties and fifties. They help Sarah manipulate the large molds.

"They are so quick and nimble. Watching them is like viewing a choreographed dance," she said. "Their movements are so succinct, yet they are able to talk and enjoy themselves as they work. They're wonderful in assisting me. I work on one piece for a really long time. They produce paper all day. When they have their coffee break, they help me. They have taught me a great deal about technique and true collaboration."

In 1987, when I began representing Sarah, she had just begun creating her paperworks, and she sent mainly her more traditional prints to the gallery. One of the first prints I saw was "Bi Bop Puddle Hop." In predominantly soft shades of yellow, pink, and black, it shows the legs of a group of schoolgirls in uniform. The reflections of their bodies are seen in the puddles in the foreground. An early work from 1984, it remains one of my favorites. "His Story," another captivating piece, is a handcolored aquatint of an older man walking down the street with a child. You see the backs of both people. This piece

has always reminded me of the walks my father and I used to take when I was a child. It apparently has a strong emotional effect on others as well. Visitors to the gallery still ask for that image, though it is long out of print.

People who see Sarah's more recent work are fascinated by both the process and the images. The Japanese influence is very evident in the imagery and the use of space. Yet Sarah's freedom of expression and the continual changes in her style and techniques definitely reflect a Western influence. As Sarah said, "There is a part of me that is attracted to the minimal Zen aesthetic. There is another part that is attracted to a very romantic Western aesthetic."

It is this blend that has always made Sarah's work so appealing to me. Currently Sarah continues to send me a variety of styles in different media, as she finds it stokes her creativity to be moving back and forth between pieces.

"Changing parameters keeps me from repeating myself. I often switch between making prints and paperworks. I tend to find solutions for one image while working on another; thus I work on two images simultaneously. I move between mediums, between images, and between cultures, East and West. Working in two cultures with different materials and points of reference has allowed me a certain degree of freedom and a continually refreshed vision."

Sarah travels to New York approximately twice a year to create paperworks at Dieu Donné. At the New York studio, she uses a fine linen cloth that has been beaten back into pulp. The fiber, which is short, holds a lot of powdered pigment, enabling her to make strong, vibrant colors and bold, expressive images. Her New York paperworks provide a striking counterpoint to the pieces she creates in Japan, where the long fibers lend a softness to her images. The latter images fit in beautifully in my gallery.

In 1995, I visited Sarah at her Japanese home in Kyoto where she lives with her husband, Masa Fujiwara, a designer of custom-built homes. His most recent challenge is designing a summer home in the Himalayas for a Tibetan rinpoche. Sarah said the experience of going with the monks to Ladakh in northern India and painting on location has definitely had an influence on the colors and intensity in some of her recent work.

Sarah's present studio in Kyoto, a converted obi factory where the sashes for kimonos were once made, is large and spacious in feeling (fifty tatami mats). In contrast to her first workspace, she can step back nearly thirty feet. The peaked ceiling is fifteen feet at the highest point. "This may sound weird," she said, "but I feel like my ideas soar up to the ceiling and encapture the whole room."

While in the studio, we ate soba noodles and Sarah showed me the series of small (eight-and-a-half-inch-square) pieces she had been working on. These intimate works contrasted with the twelve-foot-long paperwork screen we decided to unwrap that afternoon. We stepped back to view "Biwako Blue," a magnificent work of art, depicting a vast mountain range.

In 1992, Sarah created her largest pieces to date when she was invited to be the first artist ever to exhibit at the famous Byodo-in in Kyoto, a treasured temple from the Heian period (A.D. 1074). Thirteen paperworks were displayed outdoors on the walls of the Kannon-do, a national landmark dating back to the seventeenth century.

She explained the intriguing issues involved, "When you look at art in a gallery, you're in a controlled environment. Usually the space is very bare and the lighting constant. Byodo-in has a fantastic garden and wonderful architecture surrounded by chang-

ing daylight. It was a real challenge to make art that would both harmonize and hold its own in this strong environment.

"I would go and sit in the temple garden and allow myself to dream about what I would see on these walls. I decided to make works that were very fluid and full of motion, to contrast with the symmetrical architecture," Sarah continued. "I built a little model of the building to figure out how big the pictures needed to be. Since the paper-works would hang outside, I also had to think about the possibility of rain, about the pigeons who lived in the eaves."

In addition to the important Byodo-in exhibit, Sarah's work has been shown internationally in more than forty solo shows. Autumn 1995 included solo shows in Tokyo, New York, and Paris. Her work has been collected by the British Museum, Cincinnati Art Museum, the University of Rochester Memorial Art Museum, and the Zimmerli Museum at Rutgers University.

Since coming to Japan in 1979, Sarah's work seems to be more and more about freedom.

"You're looking for that clear inner essence of who you are," she said. "I think more and more my work is moving in an intuitive direction. In my best moments, my work takes me out of a self-conscious place and puts me in a very free place. Part of what is so wonderful about working in the medium of paper is that the pace of the work and the rhythm allow me to work in a stream of consciousness. The images are literally pouring out, and I don't know consciously where they're coming from. I have a very active mind, but when I'm working, it takes me out of that. I'm able to take risks that I probably don't in everyday life. That is very liberating!"

サラ・ブレイヤーはニューヨーク州ロチェスターで生まれ，1979年以来，日本に住んでいる．彼女の初期の版画のテーマは，「自然の中の日本人」というもので，見る人に各自の生活の中の出来事や感覚を容易に連想させるものである．サラは相変わらずエッチングやアクアチントの製作を続けているが，ペーパーワークにも深く魅せられるようになっている．これは着色された紙パルプによって形づくられた形象を竹製のスクリーンの上に置き，ブラシを用いずにスクリーンを傾けたり，水を噴霧したりすることによって形を整え，手彩色するものである．彼女は「未知の世界に飛び込めば，自分の足跡を発見できるのです」と言う．そのような一連の試みを通して，サラは日本で有能なアメリカ人美術家として名を成すことよりも，新しいユニークな様式を創り出し，それに熟達した人になることを選んだのである．「紙という素材で仕事をする素晴らしさは，仕事の流れとリズムを自覚しながら進められるということです．イメージは文字どおり涌いてくるのですが，それがどこから出てくるのかは私には分かりません．日常生活の中には存在しない危うさに，私は賭けることができます．それこそ自由というものなのです」と語っている．

サラ・ブレイヤー「波動」（紙，スクリーン，1994年）
サラ・ブレイヤー「ぴちゃぴちゃ，ちゃぷちゃぷ」（木版，Ed.150，1984年）
サラ・ブレイヤー「姉妹」（紙，ステンシル，Ed.10，1995年）
サラ・ブレイヤー「被りもの」（コログラフ，シーヌ・コレ，Ed.3，1996年）
サラ・ブレイヤー「お話」（アクアチント，手彩色，A.P.，1987年）
サラ・ブレイヤー「琵琶湖の青」（手漉き和紙，スクリーン，1988年）

Sarah Brayer. *Surge*. Paperwork screen. 1994

33/150 Bi Bop Puddle Hop Sarah Brayer 84

Sarah Brayer. *Bi Bop Puddle Hop*. Woodblock print. Ed. 150. 1984

6/10 Sistas Sarah Brayer 95

Sarah Brayer. *Sisters*. Paperwork, stencil. Ed. 10. 1995

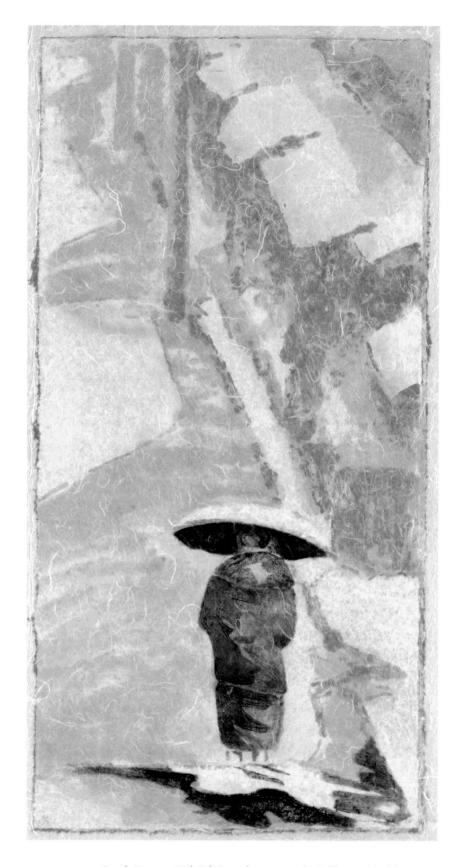

Sarah Brayer. *Veil*. Editioned paperwork. Collograph with
chine collé. Ed. 3. 1996

Sarah Brayer. *His Story*. Aquatint with handcoloring. A.P. 1987

Sarah Brayer. *Biwako Blue*. Kozo and mitsumata paperwork screen. 1988

T he smallest treasures in the gallery are the woodblock prints of Micah Schwaberow. His favorite subjects are subtle landscapes and the female figure. Visitors to the gallery immediately fall in love with Micah's work, but they only notice his woodblock prints if I display them in a very special place. This is due to the fact that many of the pieces are as small as three-inches square.

"I'm really interested in working small," Micah says. "It forces me to condense what I'm trying to say. If you only have a small space to work in, you have to choose carefully and everything matters. I think of my work as color haiku, large places compressed, intimate glimpses through small windows."

He continues, "People have often asked me why I don't make a really large print. If I go to the beach and I pick up a broken piece of shell and it's very beautiful to me, it never crosses my mind, 'If only this were six feet tall, then it would be really swell.'"

MICAH
SCHWABEROW

Mokuhanga, traditional woodblock printing, is especially suited to Micah's skills, beliefs, and modest personality. The craft aspect of the woodblock-print medium particularly appeals to him. He never calls himself an artist, but rather a craftsman. He likes using tools and taking care of tools, and he likes "the challenge of figuring out all the pieces that go together to make the final image" of a woodblock print. But he admits that during the difficult print-proofing stage, he and his wife joke about pitching a tent for him in the backyard because he becomes so hard to live with.

Woodblock printing also enables Micah to "paint with the blocks." During the testing stage, he can work extensively with the colors, inking and proofing over and over again, in a way that watercolors won't allow. He also likes the quality of the color in a woodblock print—how deeply the color seeps into the paper and the way the color shines through it.

With regard to color, he says, "I'm really interested in exploring a narrow range of value and color, so my work is never pyrotechnic. I think there's an electricity that can happen when a very soft warm comes into some subtle cools."

The fact that woodblock printing is a process involving multiple copies that are signed and numbered enables this very private artist to make a living. Micah would never consider selling his drawings because they are very personal—"like a diary." But once he's made multiple copies of a print, he feels comfortable "giving one to a friend, selling some, keeping one for his daughter Kyla." He also likes this aspect of printing because it enables him to charge less for his artwork.

"I'm supported by people like myself who couldn't afford to buy expensive artwork," Micah says. "It's important to me that they don't have to buy a poster, that they can buy something somebody made."

Some of Micah's woodblock prints are presented in "suites"—sets of five to seven prints, housed in a fabric-covered "box."

"By putting them in a box, people only see them by intention—only look at them

when they mean to—in a very intimate way, holding them in their hands and turning the pages like a book," Micah says.

To explain his first suite, "Homage to Monet," Micah uses an analogy to music, "For most of the musicians I know, it never crosses their minds to compose anything. They're fine craftsmen with great virtuosity. I got curious what it would be like to 'play Monet on the woodblock.'"

Other suites of Micah's include landscape scenes of Yosemite and Point Reyes National Seashore, and fragments of shells found at the beach.

Micah speaks respectfully of the many teachers in his life who have led him to his current work. Especially important to him are Maurice Lapp, his painting teacher, and Elizabeth Quandt, who introduced him to printmaking, specifically etching, in 1979. Micah and his wife Linda were making a living at the time creating wooden toys, and Micah's natural affinity for wood led him from etching to woodblock printing. After a frustrating period on his own, he signed up for a two-week class with a young Japanese printmaker, Yoshimi Okamoto, who was teaching in nearby Mendocino County.

Micah became so enamored of the medium of woodblock printing that he and Linda began saving money and learning the Japanese language with the hope of going to Japan to study. Micah laughs when he says "It's one thing to say 'Where's the bathroom?' and another to say 'How do you control the moisture content of the paper?'"

The Japanese printmaking teacher provided Micah with the link to Toshi Yoshida, a master printmaker and son of the famous artist Hiroshi Yoshida. With his wife's encouragement, Micah attended Toshi Yoshida's one-month class for foreigners in Miasa, Japan. Micah soaked up all he could, thinking he might never return.

"From Toshi I was learning about color, about how to overlay the transparent colors, how to separate the image into components and put it back together like a puzzle," Micah says. From Hideo Yasumoto, one of Yoshida's carvers, Micah learned "things about sharpening tools and remaking the tools to fit your hand."

And then there were the experiences that had nothing to do with printmaking. Micah was one of the few students who stayed at the workshop all the time, and so did Toshi Yoshida. He and Yoshida were often the only ones there working in the evenings.

"Late one night, we were sitting in the mokuhanga room. Toshi started playing a drum and I started playing this little gourd instrument. We played for an hour or so. That experience is beyond language," Micah says.

But a month of woodblock printing wasn't long enough. Back in California, Micah worked on a print he had started of Toshi Yoshida's mother, who was ninety years old when he met her in Japan. When Toshi Yoshida saw this print, it convinced him that Micah was serious. With this encouragement, Micah, his wife, and his daughter made the decision to move to Nagai, two hours from Tokyo, in 1982. This time it was for a year's stay.

The first evening in Japan, sitting in Toshi Yoshida's living room having tea, one of the first things the master said was, "By the way, I don't teach."

At that moment, Micah seriously wondered why he had uprooted his family and moved halfway around the world. But one of the first things he learned in Japan was how to be a good student.

"Here [in the United States], the student is like a bird with its mouth open, being fed by the teacher. In Japan, it wasn't anybody's responsibility to teach me, it was my responsibility to learn."

In Tokyo, where Micah worked on his printing, Toshi Yoshida lived on the second

floor of the building, and the first floor consisted of rooms in which three or four printers worked full time on Yoshida's prints. Micah did his printing in a small, dark room off the main room. After some very frustrating attempts to work by himself, Micah came to an important decision. "I realized my only hope was to befriend the printers. It was the technicians I really needed to learn from. So eventually I got permission to stand in the corner of their room and watch the printers print."

He didn't ask questions, he just watched. "After weeks and months of this, I realized that what I needed to learn was about their ballet—the working dance rhythms of their printing. So I would watch for many hours of the day, and then I would go back and work on my own print."

Sometimes, when the printers would come back to the sink, which was located in the room where Micah worked, they would pause and rearrange his printing setup. Or they might reposition his hands on a tool.

One morning, Micah was watching all four of them working on one of Toshi Yoshida's very large prints. "I was watching for some hours when one of the younger printers, Numabe, stopped what he was doing and handed me his brush and baren. I had to step in and be the fourth printer, doing everything exactly as he had been doing it, and I couldn't mess up. They let me do that for a few printings, then Numabe took his tools back."

Micah says they were testing him. He felt he had to convince them through his patience that he was serious, that he really wanted to learn the craft.

"One day," he continues, "I was working in the dark room. I had a little cloth rag with oil on it that the baren sits on. Each professional printer had some kind of black cloth, like a thick felt, that he placed his baren on during printing. Heihachi Komatsu, the senior printer, came by while I was printing and took my cloth rag and put down one of those black-felt cloths. He did it in the rhythm of my printing so that when I put my baren down, the black cloth was there. I felt like it was my diploma."

Micah says he never received praise from anyone, and he assumed it wasn't a Japanese custom. The closest he came to positive feedback was when Toshi Yoshida and the carver Yasumoto were looking at a print Micah had tacked to the wall. Micah was cleaning brushes on the other side of the room when he heard Yoshida say to the carver, "Yoku dekimashita," which means well done.

But the reassurance Micah needed came on a summer day when Yoshida matter-of-factly informed Micah that he was to be an assistant at the next month-long class for foreigners. Micah felt in some way that he had arrived.

At the end of the year, Micah returned to his home and studio in Santa Rosa, California, much better equipped to pursue his craft. He finished some of the Japanese images he had started in Japan. But fairly quickly, he began making images from California. His work from that period, and more recently, include "Morning, Tuolumne River," "Laguna," "Spring Lake," and "Evening Light, Mouth of the River." Generally, Micah's prints require eight to ten blocks and anywhere from twelve to fifteen impressions, using either the baren or his handcranked Vandercook press.

His landscapes look very much like watercolors, except for the telltale grain of the woodblock on some of the prints. This is partially because Micah has eliminated the dark lines that normally define the shapes in a traditional woodblock print.

"I am trying to make woodblock prints that don't look like woodblock prints—the wood and the knife invisible, the colors and edges as soft and resonant as a watercolor," Micah explains.

It is this quality that attracted me to Micah's prints when I first saw them in *Journal of the Print World*. I was also looking for an artist who did traditional landscape prints. Many artists were switching to more modern and abstract imagery, whereas Micah's work retained the Japanese feeling, using California images.

When I began talking with Micah on the telephone, it was rather difficult to do business because he has very strong principals and particular restrictions for selling his work. Upon meeting him in San Francisco, I realized he is a very kind person, whose intentions are sincere. I am willing to adhere to his rules in order to represent him because I feel he is one of the most skilled woodblock printmakers in the United States. In 1995, when I suggested a one-man show for September of the next year, Micah politely declined, saying he was going to be busy with a few fundraisers at that time. I replied, "Micah, just let me know when you want to be famous."

But Micah is not thinking about fame. He is concentrating on the two very different aspects of his work—his landscapes, which are about color and place, light and time of day; and his figure work, which is more about line and movement.

"But I think there's a common thread between the two," he says. "If I had to have a word that is the theme, I think the word is *homage*. I think if you look at the things I've made, I'm somewhat invisible. I'm not trying to talk about myself—at least it's very indirect. I'm just trying to honor what I see—whether its landscape or figure."

Micah hopes that his reverence for his subject matter comes through to the viewer and "acts as a kind of medicine, or like a little piece of healing."

He hopes that for those who have "his small images in their daily lives, it reminds them of another way of being or paying attention.

"I'm interested in honoring a small event or an event that isn't Mount Fuji," Micah says, "in hopes that it will help people see that they're surrounded by these small, magical events in their lives, but maybe they forgot to notice."

マイカ・シュワベローはカリフォルニア州サンタローザに住んでいる．彼は版画家，吉田遠志に1年間学んだのだが，吉田の版画作品「バレー」の製作工程を多大な忍耐と敬意を以て観察し，それを自分の作品に取り入れることにした．シュワベローの版画は非常に小型で，主として繊細な風景と女体の線画とから成っているのだが，小型にすることによって，表現したいことを濃縮できるのだと説明している．また，自分の作品については「カラー俳句であり，圧縮された大風景であり，小さな窓からちらっと見えた心象風景である」と見なしており，そのテーマが見る人に満足を与え，「一種の薬になったり，治療になったり」することを願っている．彼は「小さな作品，あるいは富士山ではない作品を大切にすること，また人々が日常生活における小さな不思議なことを発見するお手伝いをすることに興味があるのです．おそらくは人々はそれを意識することに気づかないでしょうけれども」と語っている．

マイカ・シュワベロー「山下家の上」（木版，Ed.187，1982年）
マイカ・シュワベロー「河口の夕明かり」（木版，Ed.61，1994年）
マイカ・シュワベロー「冬の人」（木版，Ed.38，1994年）
マイカ・シュワベロー「髪を梳く」（木版，Ed.48，1990年）
マイカ・シュワベロー「春の湖」（木版，Ed.63，1994年）
マイカ・シュワベロー「小さな湖」（木版，Ed.57，1994年）
マイカ・シュワベロー「鬼太郎山の月の出」（木版，Ed.52，1994年）

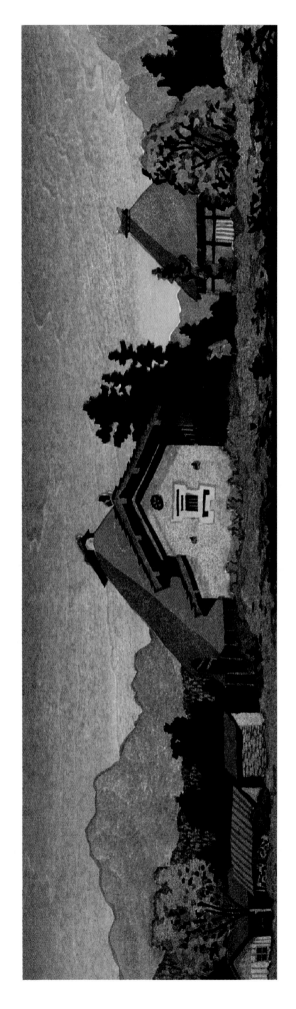

Micah Schwaberow. *Above Yamashita's*. Woodblock print. Ed. 187. 1982

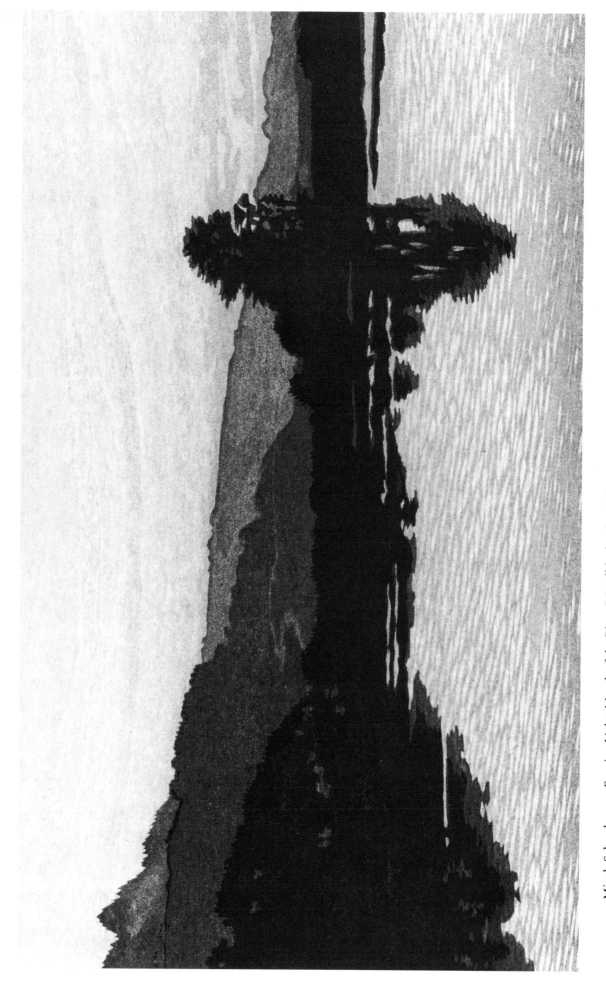

Micah Schwaberow. *Evening Light, Mouth of the River.* Woodblock print. Ed. 61. 1994

Micah Schwaberow. *Winter Self*. Woodblock print. Ed. 38. 1994

Micah Schwaberow. *Combing Her Hair*. Woodblock print. Ed. 48. 1990

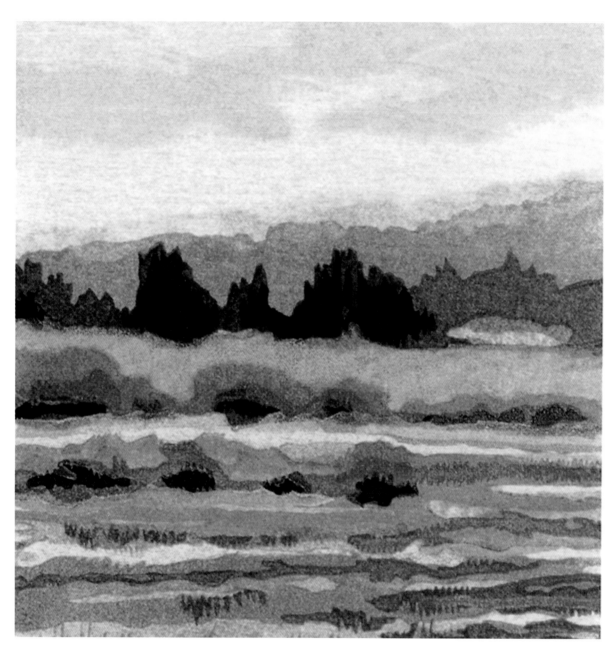

Micah Schwaberow. *Laguna*. Woodblock print. Ed. 57. 1994

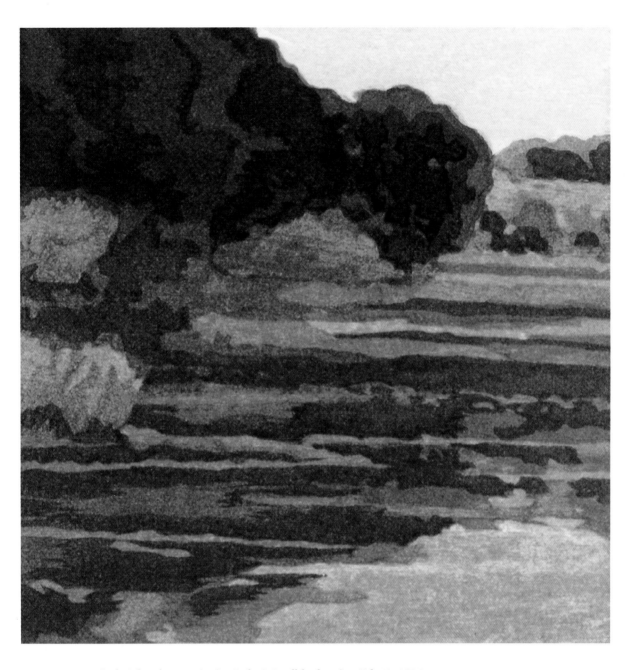

Micah Schwaberow. *Spring Lake*. Woodblock print. Ed. 63. 1994

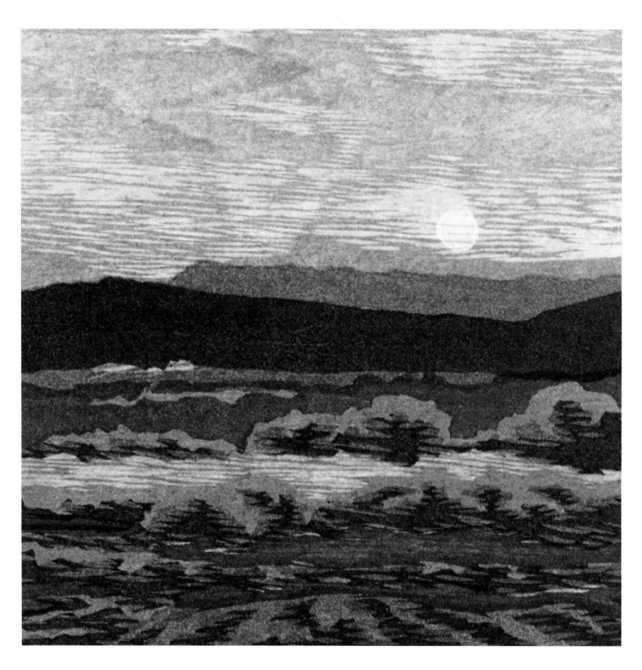

Micah Schwaberow. *Kitaro Moonrise*. Woodblock print. Ed. 52. 1994

LIST OF ILLUSTRATIONS

DANIEL KELLY

Snowflakes I. Lithograph. Ed. 7. 1984

Snowflakes II. Lithograph. Ed. 7. 1984

Walking in the Rain. Watercolor. 1984

Letters from Kyoto. Watercolor, chine collé. 1995

Children's Parade. Woodblock print. A.P. 8/30. 1981

Buttercups. Woodblock print. A.P. 1/25. 1982

The Secret. Cement block, woodblock, lithograph, handcoloring. Ed. 32. 1994

Straight Away. Woodblock, lithograph, handcoloring. Ed. 32. 1994

Junko. Woodblock print. Ed. 50. 1989

Junko. Keyblock.

Strawberries. Woodblock, lithograph, cement block, handcoloring. Ed. 20. 1990

Ancient Blue. Watercolor. 1996

KARYN YOUNG

Ocha (Tea). Pastel, acrylic, and collage. 1996

Sea Bound. Silkscreen print. Ed. 70. 1989

Tsuru (Crane). Pastel, acrylic, and collage. 1996

Tea for Three. Woodblock, lithograph, and chine collé. Ed. 35. 1993

Itadakimasu. Woodblock, lithograph, and chine collé. Ed. 35. 1993

Fish Gotta Swim. Stencil-dyed, silkscreen, lithograph, and chine collé. Ed. 50. 1993

Spring. Silkscreen print, with chine collé, stencil-dyed, and handcoloring. Ed. 48. 1991

JOSHUA ROME

Inagi (Rice Drying). Woodblock print. Ed. 90. 1990

Kikori (Logging). Woodblock print. Ed. 100. 1984

Fuyu No Hi (Winter Day). Woodblock Print. Ed. 100. 1981

Seijaku (Quietness). Woodblock print. Ed. 95. 1991

Enryo no Katamari (The Last One). Woodblock print. Ed. 95. 1986

Tau-e. Woodblock print. Ed. 100. 1981

Amawaka No Harusame (Spring Rain in Amawaka). Woodblock print. Ed. 100. 1986

MARGARET KENNARD JOHNSON

Harvest. Intaglio relief. Ed. 20. 1976

Silent Comment. Relief, sculptured paper. Ed. 10. 1989

Beyond the Window. Relief. Ed. 10. 1994

Homage to Future Relics. Intaglio relief. Ed. 20. 1977

Where. Intaglio relief. Ed. 30. 1982

Past Presence. Intaglio relief. Ed. 15. 1990

Unfolding Thought. Relief, sculptured paper. Ed. 10. 1989

JOEL STEWART

Floating World. Etching with handcoloring. Ed. 95. 1992

Rosanjin. Watercolor. 1996

Kiri Ga Hareta. Watercolor. 1996

Tsubo. Watercolor. 1996

Looking Back. Etching with handcoloring. Ed. 67. 1994

CAROL JESSEN

Ecce Panis (Here Is the Bread) Woodblock print. Ed. 50. 1995

Morning Mist. Woodblock print. Ed. 20. 1982

The Paper Makers. Woodblock print. Ed. 75. 1992

Kozo. Woodblock print. Ed. 75. 1994

Reflections. Woodblock print. Ed. 70. 1985

Villete Live Art. Woodblock print. Ed. 80. 1996

The Promenade. Woodblock print. Ed. 55. 1986

BRIAN WILLIAMS

Boka Yosui (Firewater). Oil. 1992

White Morning. Etching. Ed. 180. 1996

Snow Light. Etching. 1994

Yuki No Hi (Snowy Day). Watercolor. 1995

Evening Song—Katata. Monotype. 1996

After the Rain. Watercolor. 1991.

SARAH BRAYER

Surge. Paperwork screen. 1994

Bi Bop Puddle Hop. Woodblock print. Ed. 150. 1984

Sisters. Paperwork, stencil. Ed. 10. 1995

Veil. Editioned paperwork. Collograph with chine collé. Ed. 3. 1996

His Story. Aquatint with handcoloring. A.P. 1987

Biwako Blue. Kozo and mitsumata paperwork screen. 1988

MICAH SCHWABEROW

Above Yamashita's. Woodblock print. Ed. 187. 1982

Evening Light, Mouth of the River. Woodblock print. Ed. 61. 1994

Winter Self. Woodblock print. Ed. 38. 1994

Combing Her Hair. Woodblock print. Ed. 48. 1990

Laguna. Woodblock print. Ed. 57. 1994

Spring Lake. Woodblock print. Ed. 63. 1994

Kitaro Moonrise. Woodblock print. Ed. 52. 1994